Enchanting
AUSTRALIA

DAVID BOWDEN

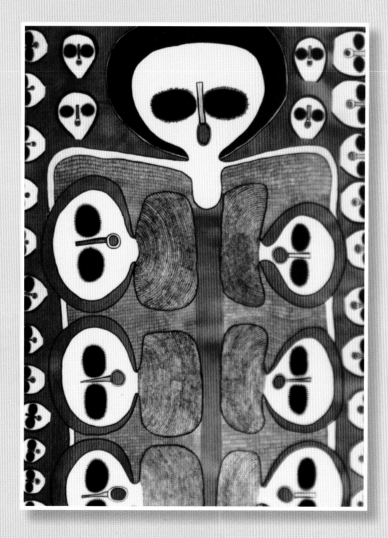

JOHN BEAUFOY PUBLISHING

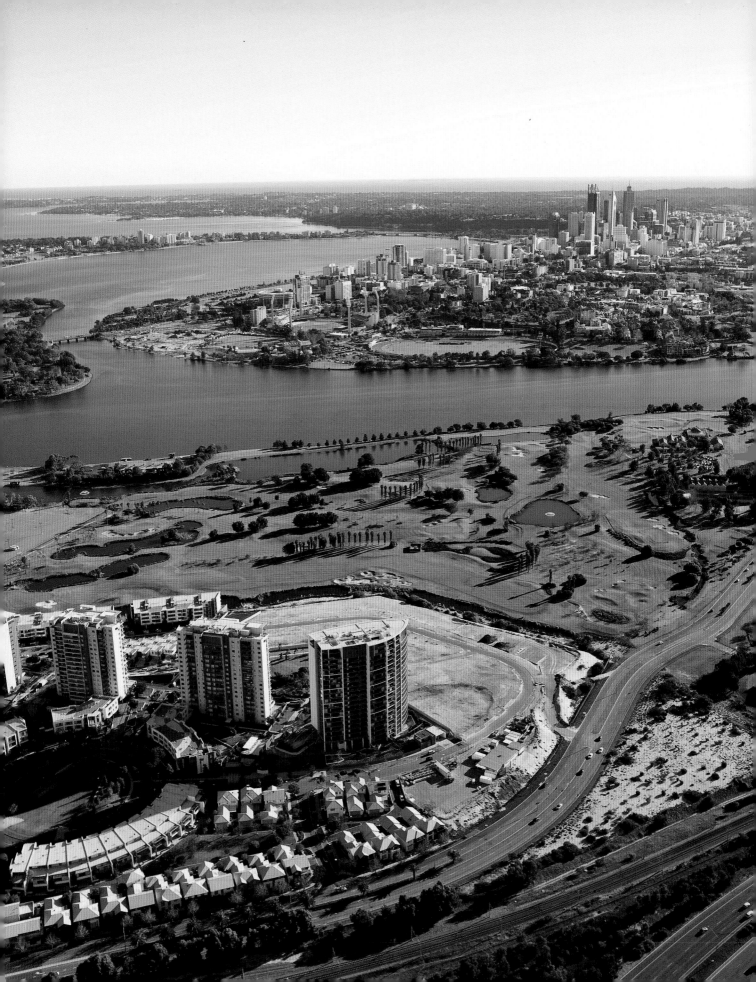

Contents

Above: Much of Australia's fauna, such as the kangaroo, evolved in isolation.

Above centre: Wollemi National Park to the west of Sydney

Above left: The Great Barrier Reef is the world's largest coral reef system.

Opposite: Australia is a young country; Perth, the Western Australia capital, was only settled in 1829.

Title page: Aboriginal artist, Sandra Mungulu's image of Wandjina, the creation of the West Kimberley, Western Australia.

Chapter 1: The Lucky Country

Most visitors who fly from Europe and Asia will enter Australian airspace over Derby in Western Australia. During the five-hour flight from here to the eastern states, passengers will notice just how flat, dry and empty much of the country really is.

The Commonwealth of Australia is the only country that is also a continent. It is also the world's largest island and the sixth largest country by area (there are actually many smaller outlying islands including the large island state of Tasmania, Melville Island and Kangaroo Island). It has no land borders and has the world's largest area of sea under its national jurisdiction. The nation covers an area of almost 7,700,000 sq km (2,970,000 sq miles) and with a population of just 23.6 million people, this means it has a population density of three people per square kilometre (1.15 per square mile) to ensure it also has the planet's most sparsely distributed population, though these figures are misleading as Australia is one of the world's most urbanized countries with 89 per cent of its population living in coastal cities predominantly in the far south-eastern coastal strip from Melbourne to Brisbane. The exception is Canberra (including Queanbeyan in neighbouring New South Wales), the capital city and eighth largest urban area, which lies roughly 150 km (90 miles) inland from the coast. Most Australians live in the suburbs of large cities and appreciate their space with their own backyard, although rising real estate prices mean that many city dwellers now live in high-rise apartments.

The Commonwealth includes the six states of New South Wales (NSW), Victoria, Queensland, Tasmania, South Australia (SA) and Western Australia (WA) and ten territories. The latter include the Australian Capital Territory, the Northern Territory and Norfolk Island, which has been granted limited self-government. Other territories include Ashmore and Cartier Islands, Christmas Island, Heard and

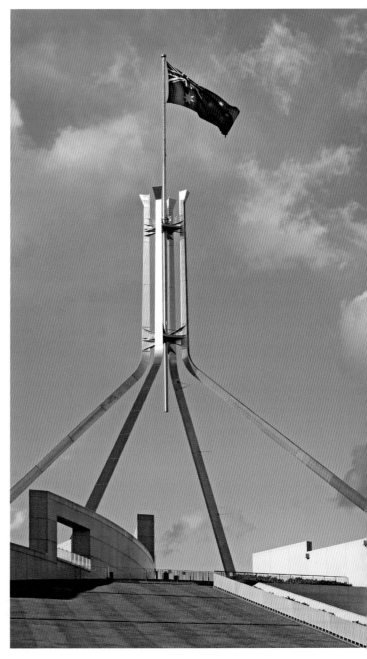

McDonald Islands, Coral Sea Islands, Cocos (Keeling) Islands as well as the Australian Antarctic Territory. Lord Howe Island is administered by the state of NSW.

Australia is an ancient land dating back possibly four billion years with an abundance of ancient rocks and fossils. The Great Artesian Basin that lies beneath 23 per cent of central and north-east Australia is the world's largest and deepest basin. Bore water sourced from the basin provides a reliable supply of fresh water in these often parched areas. Some of the rocks are mineral rich and Australia exports raw resources such as coal, iron ore, nickel, aluminium, diamonds, copper, gold and uranium. Many of the mines are huge and located in isolated areas, staffed by workers who fly in and fly out every few weeks. Other main exports include natural gas, grains, wool and food products.

Many farms or stations are larger than nations (if the cattle ranch of Anna Creek Station in South Australia were a country, it would be the 150th biggest country in the world and larger than countries such as Belize, Israel, Kuwait, Qatar, Lebanon and Hong Kong).

Australia is an active member of the United Nations and the Commonwealth of Nations. In recent decades, its sphere of influence and future planning have moved more towards the Asia-Pacific region and away from Europe.

A combination of the wealth gained from the export of resources, the climate and the lifestyle has contributed to Australia being known as the 'Lucky Country' as it is considered to offer boundless opportunities.

Above: The Australian economy once 'rode on the sheep's back' but the services sector is now the biggest contributor to GDP.

Opposite: The Australian Parliament sits in Canberra in a landmark building that was opened in 1988.

Geography and Climate

Located in the southern hemisphere, continental Australia is dissected by the Tropic of Capricorn and extends west to east from 113°E to 154°E (a distance of some 4,000 km/ 2,500 miles) and north to south from 11°S to 44°S (roughly 3,200 km/2,000 miles). It also has a vast coastline of 37,000 km (23,000 miles) with an Exclusive Economic Marine Zone around it that extends for 371 km (200 nautical miles), making it the second largest such zone in the world after the USA. The continent is surrounded by the Indian, Pacific and Southern Oceans and its nearest neighbour is Papua New Guinea to the north.

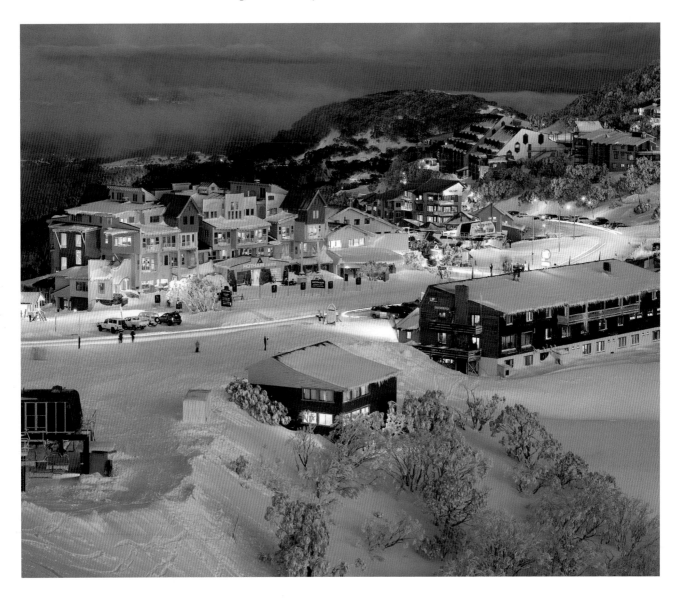

Australia's distinctive geographical areas are the Eastern Highlands along the east coast, the Central Basin and the Western Shield, comprising ancient and mineral-rich rocks. The Central Basin is mostly desert but several large, seasonal lakes fill after the occasional downpour and refill large aquifers like the Great Artesian Basin. Vast areas of the 'outback' or 'bush' are semi-arid or desert and some, such as the Simpson Desert and the Nullarbor Plain, have an area exceeding the size of many countries. The highest point of the country is Mount Kosciuszko in NSW at 2,228 m (7,310 ft) and Lake Eyre (SA) is the lowest point at 15 m (49 ft) below sea level.

Covering such an expanse, Australia experiences a huge range of climatic and meteorological conditions from parched arid deserts to highlands dusted with snow. A third of the country lies within the tropics where rainfall, temperature and humidity are mostly high all year round. Much of central Australia, though, has a low rainfall and high temperatures. In some parts of the country like White Cliffs (NSW) and Coober Pedy (SA), the hearty inhabitants actually live underground because of the oppressive summer temperatures. Compared to the inland, coastal areas have a higher rainfall, consequently the vegetation is more lush making it the place where most Australians choose to live.

Apart from the tropics, much of Australia experiences four seasons with summer occurring at the end of the year and winter in the middle. Melbourne weather is notorious for 'four seasons in one day'. There are three time zones: Eastern Australian, Central Standard and Australian Western and all but Queensland, Northern Territory and Western Australia implement daylight saving in summer.

While Australia is mostly free from major seismic events, such as earthquakes, it does suffer from natural disasters, such as cyclones, bushfires and floods.

Opposite: Ski resorts, such as Mount Hotham in Victoria, dispel the myth that Australia is a hot and barren country.

Right: Australians value the open space and natural beauty of such places as Castle Rock in the Porongurup Range, Western Australia.

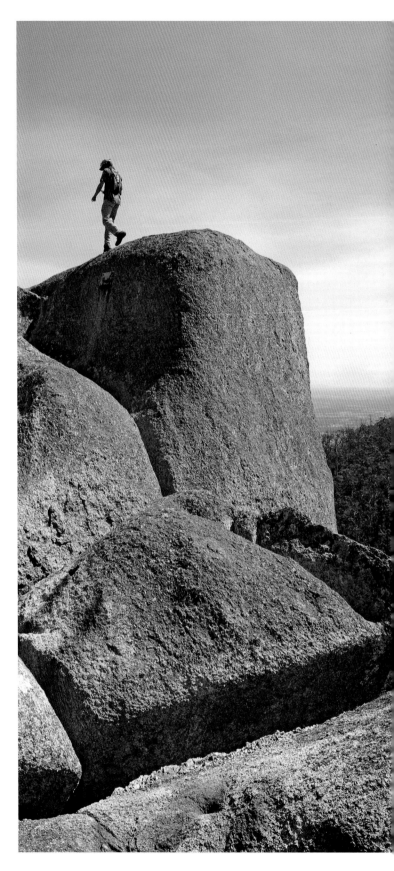

History

Australia is one of the most multicultural societies in the world; her citizens originate from many different countries (27.7 per cent of the population were born overseas). Even the indigenous Aborigines arrived from neighbouring northern countries, although this was at least 45,000 and possibly even as far back as 60,000 years ago. Australia's oldest recorded history is that of the traditional owners with some of their rock art dating back several thousand years. Examples of this art and associated carvings are located in many parts of the country with some 5,000 recorded art sites in Kakadu National Park alone.

Opposite: Sydney's Circular Quay was where the First Fleet arrived and the NSW colony was established. Some historic buildings remain around the foreshore.

Below: Sarah Island in Tasmania where some of the convicts transported to Australia were sent.

It was not until 1606 that a European first set eyes on the vast land. Dutchman Willem Janszoon is credited as the first European to sight Australia having explored the far north of Queensland. Soon after, Abel Tasman sighted Tasmania, which he named Van Diemen's Land. European mariners landed in the north and west of the country from the 17th century onwards but no permanent settlement was established until the 18th century.

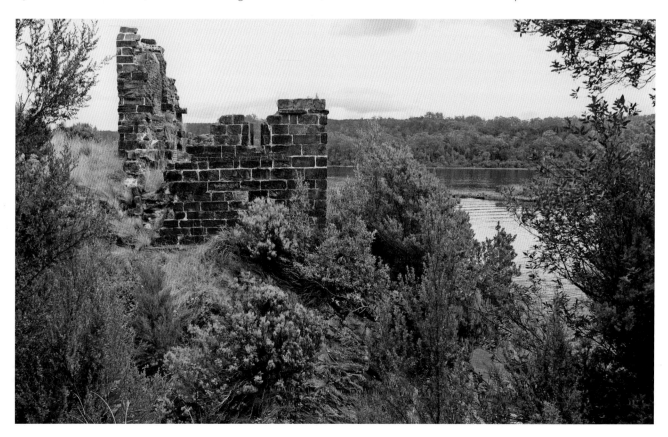

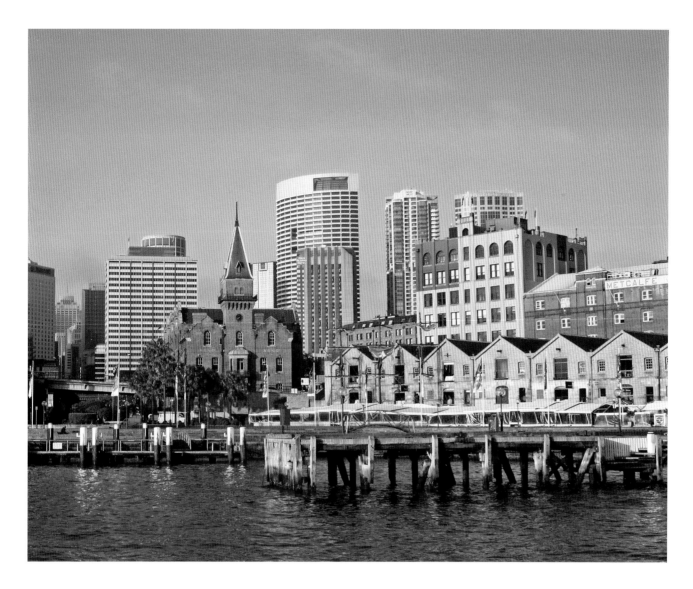

Captain James Cook landed in 1770 at Botany Bay (now part of Sydney) and proclaimed what was then known as Terra Australis Incognita for the British. Following this, the state of New South Wales was colonized in 1788 by the First Fleet, a convoy of 11 British ships and some 1,500 people (convicts and their charges), which set sail from Portsmouth in May 1787 led by Captain Arthur Phillip. Botany Bay was the site of the first temporary settlement but, on 26 January 1788, the settlers relocated north to what is today known as Circular Quay on Sydney Harbour (officially Port Jackson). This day is now celebrated as the Australia Day national holiday. The settlers beat French adventurer Jean-François de La Pérouse by a few days to ensure that Australians from then on spoke English and not French. Further colonies were established in Tasmania (1803), Queensland (1824), Western Australia (1829), Victoria (1834) and South Australia (1836).

Australia is the only country that started as a prison. Convicts were transported here to penal colonies as a solution to England's then-overcrowded prisons, a practice that continued until 1868 when the last boatload arrived in Western Australia. Macquarie Harbour Penal Colony on Sarah Island in the far south-west of Tasmania was one of the harshest in one of the most remote parts of the world.

Australia came to the attention of the rest of the world when gold was discovered in central NSW in 1851. This

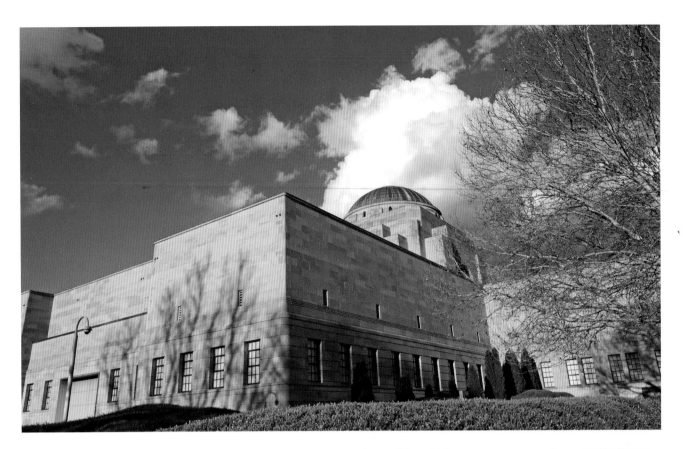

swelled both the economic coffers of the various colonies and the population: immigration grew by 600,000 in the decade following the first discovery. Migrants came for other reasons, too, with the town of Broome (WA) attracting pearl divers from Japan and China, as can be witnessed by the headstones in the local graveyard.

Australia officially came into existence in 1901. In 1891, the colonies started talks about federation, which culminated a decade later in the establishment of the Commonwealth of Australia, and the colonies being renamed as states and allowed by constitution to govern themselves in their own right. Melbourne was chosen as the interim capital until a site for the national capital was chosen. Canberra was identified as that site because it is equidistant between Melbourne and Sydney, which were the largest cities. An international competition to design the new capital city was won by American architect Walter Burley Griffin and his wife, Marion Mahony Griffin. The first Commonwealth Parliament House opened in 1927.

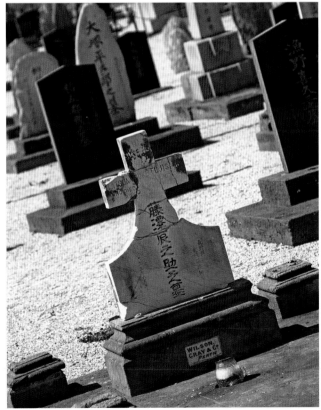

As part of the British Empire, most Australian states sent troops to fight in South Africa during the Boer War from 1899 to 1902. When the First World War was declared in 1914, Australia supported Great Britain and sent troops to Europe. The first 30,000 Australia and New Zealand Army Corps (ANZAC) troops set sail from King George Sound near Albany in the south-west of Western Australia. For many, this was the last time they would see their homeland as many died on the battlefields of Europe. In 1915, Australia lost considerable numbers of troops in their first engagement at Gallipoli in Turkey. Australian forces also fought in the Second World War, Korea, Malaya, Vietnam, Iraq and Afghanistan, and they have contributed to United Nations peacekeeping missions in various parts of the world. Australians remember their war dead from many global battles on 25 April, ANZAC Day. Services are held throughout Australia and in countries where Australian troops fought, including a dawn service at Lone Pine,

Gallipoli. In addition to Gallipoli, Australian war graves are located in most of these theatres of war with the Death March Memorial in Sandakan, Sabah (in East Malaysia on the island of Borneo) being one such solemn site.

After the Second World War, Australia recognized the need to populate or perish and welcomed many displaced Europeans seeking a new life, especially those from Greece, Italy, mainland Europe, Yugoslavia and Hungary as well as Great Britain. A controversial White Australia Policy ensured that many 'New Australians' to the country in the 1950s and 1960s were from specific European countries. By 1973 this ceased to be the policy and race is now totally disregarded in the assessment of immigrants. Australia has an ongoing migration programme that includes offering assistance to refugees. Some 6.5 million migrants have arrived in Australia since the Second World War and 15 per cent of the population now speaks a language other than English at home.

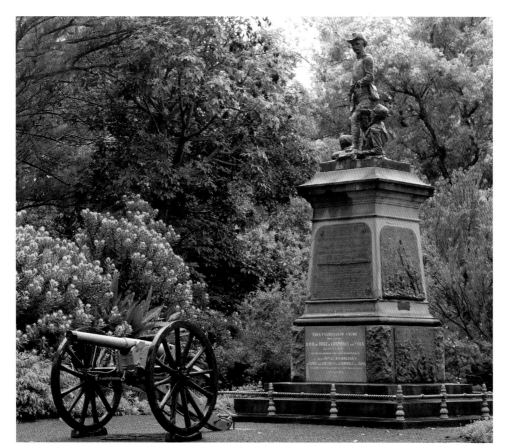

Left: This memorial in Perth's Kings Park is a tribute to Australians who died in the Boer War.

Opposite top: The Australian War Memorial in Canberra is a tribute to all Australians who died fighting for their country.

Opposite below: Broome Cemetery in Western Australia typifies multicultural Australia with its tombstones of Japanese and Chinese pearl divers who lived and died here.

People

With some 60,000 years history, the Aborigines have what is considered to be the oldest, continuously maintained culture on earth. The ancient rock art of these hunter-gatherers can be seen all over the country, and contemporary artists maintain the traditions of their ancestors.

Below: Aboriginal rock art depicting a kangaroo at Nourlangie, Kakadu National Park, Northern Territory.

Being a British colony, Australia's early links were with Britain. Over the decades though, Australia has become a multinational country enriched by immigration and now has stronger links to the Asia-Pacific region.

Australia is a constitutional monarchy of six states and several territories with the Queen of England also being the Queen of Australia (a referendum in 1999 voted against a republic and to retain the monarchy). An Australian

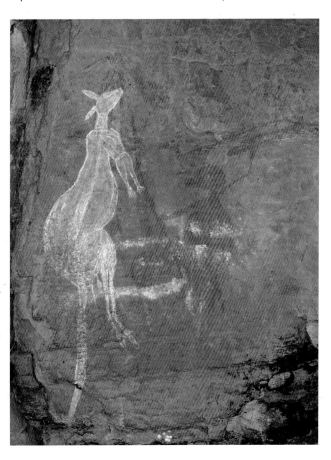

Governor-General is the Queen's representative and Australia is a member of the British Commonwealth.

Australia is the 12th largest economy in the world and its citizens enjoy a high quality of life as documented by the United Nations Human Development Index (a measure of human development, long and healthy life and a decent standard of living).

Australia is a democracy with several levels of governance from the federal to state and local governments. The Federal Government is responsible for major matters, such as tax, immigration and security, while the degree of governance becomes more localized with state and local council administration. Federal and state parliaments have two houses and voting at all levels is compulsory for eligible voters (those aged 18 and older). In 1894, South Australia became one of the world's first territories to grant universal suffrage (the right to vote for all eligible males and females).

Liberal and Labour are the two main political parties which dominate the federal and state parliamentary democracies but smaller parties such as the Greens reflect a greater awareness of the environment and social justice. Australia's Prime Minister is elected by members who hold the majority in the Federal Government.

State-school education is inexpensive and is compulsory for all up until the age of 15 to 17, depending on the state. Each state determines its own curriculum although there is commonality between all. A distinctly Australian school system is the various 'Schools of the Air' where students in remote communities are taught via two-way radio.

Australians – or Aussies as they are colloquially known – generally support the underdog and the most notorious bushranger, Ned Kelly, is revered in folk legend despite being hanged for his crimes. The concept of mateship is important to most Australians. Isolation, climatic conditions and distance have led to the development of a bond between fellow Australians who come together to help each other. This strong fellowship is an essential ingredient of society. Australian society is also egalitarian enabling people of all social, ethnic, religious and cultural backgrounds to mix freely.

English is spoken in Australia although with a distinctive accent and colourful usage of colloquialisms and slang. Despite there being slight idiosyncrasies in the language between cities, most Australians sound the same and the lifestyle is similar.

There are several important national holidays and festivals, while others are celebrated at a local level. The main national holidays are New Year's Day (1 January), Australia Day (26 January), ANZAC Day (25 April), Easter (depending on the calendar), Queen's Birthday (the closest Monday to 9 June), and Christmas Day and Boxing Day (25 and 26 December).

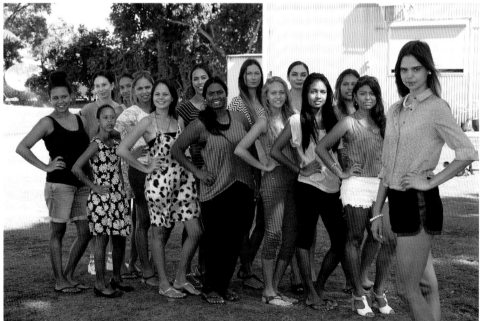

Above: Rural Australians view the world differently from those who live in the city.

Left: The Kimberley Girls are part of a personal and professional development programme based in Broome for young indigenous women from Australia's remote north-west that teaches girls life-changing skills and knowledge, and supports their future development.

Cuisine

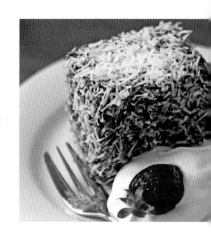

Reflecting the nation's multiculturalism, Australian cuisine is as diverse as it is complex and eclectic. First-time visitors will find lots of curious sweet and savoury Aussie food items, such as Vegemite, chicko rolls, violet crumble, cherry ripe, jaffas, ANZAC biscuits, billy tea, damper, pavlova, lamingtons and pie floaters. The locals love to introduce visitors to their iconic treats.

Like the Australian culture in general, the food eaten is constantly evolving. Australian cuisine is an all-encompassing term but these days, Australians could sit down to enjoy noodles, tom yam soup, curry laksa, dim sum or fettuccine carbonara as much as the 'meat and three vegetables' that was the staple several decades ago. One of the most visible signs of multiculturalism is the delightful variety and breadth of the fresh produce available in many Australian supermarkets and served in the nation's homes and restaurants.

Local produce

What has evolved in recent decades is the concept of Australia's own culinary style called modern Australia or Mod Oz, based on dishes that incorporate the abundance of local produce that thrives in Australian soils and in the surrounding seas. Despite much of the country being parched desert, there are extensive farmlands whose crops are cultivated by vast irrigation schemes using water from the Murray-Darling Basin plus the Murrumbidgee and Ord Rivers.

Right: Wine is increasingly important in contemporary Australian cuisine or 'Mod Oz'.

Above right: An Aussie lamington is a sponge cake covered in chocolate sauce and desiccated coconut.

Opposite top: Many wineries like Margaret River's Aravina Estate incorporate fine restaurants.

Opposite below: Melbourne's Queen Victoria Market is renowned for its fresh produce. .

With its diverse climatic zones plus pristine seas and rivers, there is very little that cannot be grown or produced in Australia. For example, the Truffle and Wine Company in Manjimup is the world's largest producer of Perigord truffles. Cattle mostly graze free-range on natural grasses and this is used as a marketing advantage against many meats and dairy products from other countries which are not so natural. Lamb and beef (including the prized Wagyu) is consumed locally and exported around the world.

The freshest seafood, such as oysters, lobsters, tuna, abalone and prawns, is sourced from rivers, oceans or aquaculture farms. Slipper lobsters, known locally as Moreton Bay bugs and Balmain bugs, provide a unique Australian dining experience. Marron and yabbies are related freshwater crayfish native to Australia and considered luxury seafood in the smartest restaurants. Many Australian food connoisseurs are particular about the geographic origins of their produce and become animated, for example, over the merits of Coffin Bay, Barilla Bay and Sydney rock oysters. Often the setting is as important as the food and there is nothing better than enjoying Australian produce in situ such as Sydney rock oysters in a Sydney Harbour restaurant or Tasmanian abalone fresh from a trawler by the docks in Hobart.

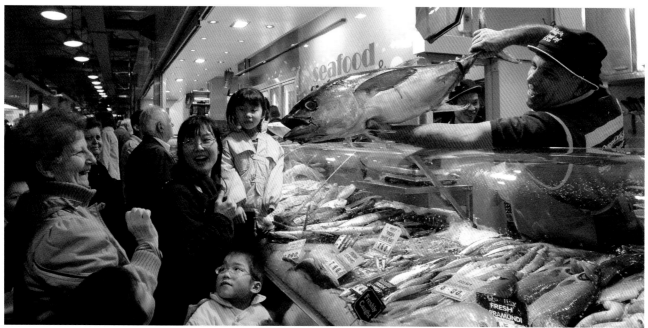

'Bush tucker' is a term used for indigenous ingredients sourced from edible flora and fauna in the Australian bush. In parts of Australia, some Aboriginal communities still obtain some of their food from their local environment. These could include lilly pilly (a fruit), karkalla (a coastal succulent), lemon aspen, mountain pepper, lemon myrtle (spice), wattleseed, finger lime (citrus fruit), quandong (fruit) and barilla (Coorong spinach). Australian animal meat, such as kangaroo and emu, and fish, such as Murray cod, are served in the smartest restaurants. The Macadamia nut (Queensland bush nut) that is endemic to north-east Australia is grown commercially and available throughout the world (while they thrive in Hawaii, they are native to Australia).

Dining out, eating in

While Australia's climate lends itself to outside dining, food in the country is not just about the ever-popular barbecue or picnic at the beach or park. However, Australia's climate

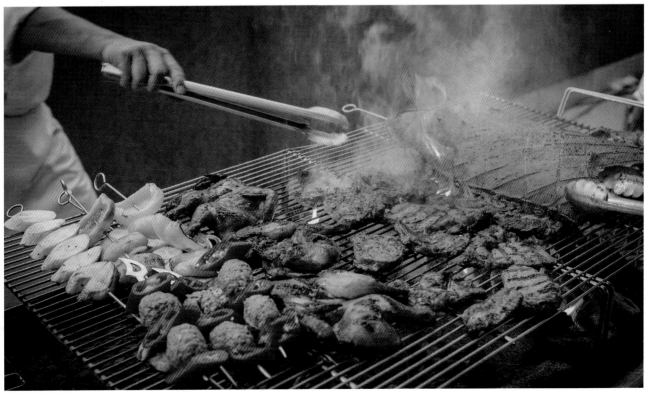

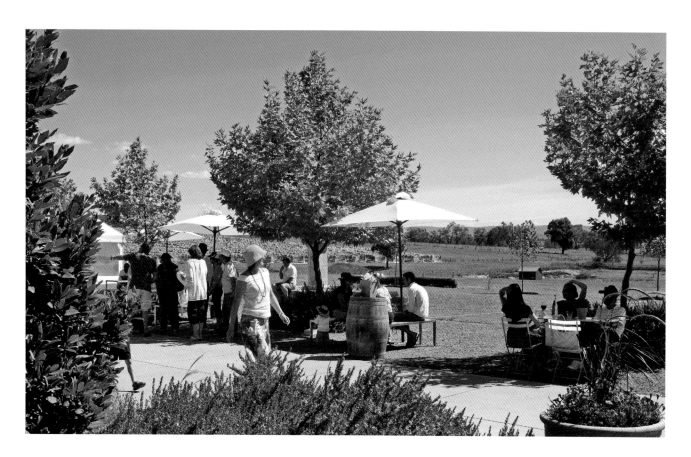

and its geographical location have a lot to do with what people eat and where they eat it. Chefs then use their skills and imagination to create dishes in their own unique style. While most are trained in classical European cuisine, some chefs enjoy the freedom that they have to experiment and not be bound down by traditions. The secret for successful cooking is not only the chef's creativity, inspiration and skill but also the ingredients used.

The mantra for most restaurants is fresh, local, natural and seasonal with the term locavore (locally-sourced produce) creeping into the vernacular. 'Restaurant Australia' is a tourism campaign which brings together people, places and produce to demonstrate the many unique and exceptional food and wine experiences that are served up daily in Australia's remarkable locations.

However, many Australians eat at home since eating out can be expensive. While some shop in local markets, large supermarkets belonging to national chains are where most buy their ingredients. Wherever they are, Australians have a growing appreciation of produce, its source and whether it is produced under organic or biodynamic regimes. Food and wine festivals are important in promoting local produce to residents and tourists. Some of the most acclaimed festivals are celebrated in Sydney (March), Melbourne (March), Adelaide (April/May), Noosa (May) and Margaret River (November). Weekend markets are to be found in most large cities and towns, and are popular with the locals for stocking up on home-made chutneys, jams and sausages, and home-grown, organic tomatoes, lettuce and other fresh fruit and vegetables. Specialty shops stock ingredients from around the globe with many being patronized by the various ethnic communities that now call Australia home.

Above: Vineyards, such as Dominique Portet in the Yarra Valley, are a great place to relax with a picnic accompanied by estate-produced wines.

Opposite page: Barbecues on various scales form an essential part of socializing in Australia.

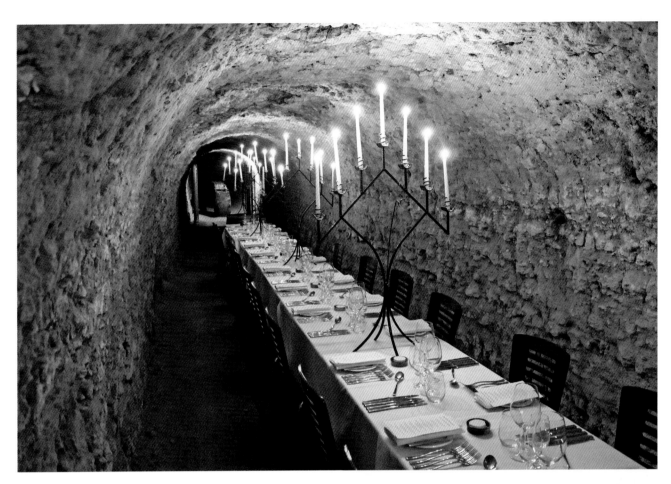

Drinks

Coffee is taken seriously especially in the cities where the coffee culture has become an art form. Greek, Italian and Turkish immigrants brought with them exotic brews, and instant coffee no longer hits the spot for most Australians. The nation's contribution to the world of coffee is the 'flat white' or 'Aussie latte' comprising two shots of espresso, steamed milk and a milky microfoam on top. Many coffee drinkers are quite parochial and loyal to independent outlets and baristas; global coffee chains have struggled to gain a foothold.

While Australia once had a reputation as a beer-drinking nation, it's now more likely that wine will accompany a meal. Australia is the world's seventh largest wine producer and wineries are located in every Australian state including the Northern Territory. There are some 65 recognized wine-growing districts of which the leading ones are Hunter

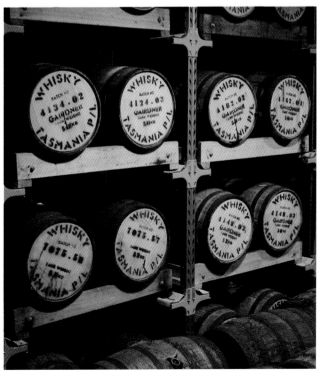

Valley (NSW), Yarra Valley (Victoria), Tamar Valley (Tasmania), Barossa Valley, Coonawarra, McLaren Vale and Clare Valley (SA), and Margaret River (WA).

Australians are justifiably proud of their local wine industry with noted international wine commentators, such as Robert Parker Jnr, claiming that the nation's iconic Penfolds Grange wine 'is a leading candidate for the richest, most concentrated, dry red table wine on planet Earth'. He is equally effusive about fortified wines especially those from Rutherglen, such as Chambers Rosewood Winery's Muscats. Both wines are regularly awarded 100/100 by wine critics. These and other iconic wines, such as Mount Mary Pinot Noir, Grosset Polish Hill Riesling, Leeuwin Estate Art Series Chardonnay, Tyrrell's Vat 1 Semillon, De Bortoli Noble One Botrytis Semillon, Giaconda Chardonnay, Torbreck The Laird and Yarra Yering Dry Red No 1, also make excellent investments and hold up well in the secondary wine auction market.

However, Aussies do still enjoy beer as produced by several well-established companies and a growing number of craft brewers. Some of the best-known beers include Foster's, Castlemaine XXXX, Tooth, Tooheys, Carlton, Hahn, Coopers, Boag's, Cascade and James Squire. Small, localized, artisanal beer brewers cater to a more discerning palate with some of the most exciting brews being Moo Brew, Little Creatures, Feral Brewing, Matilda Bay, Seven Sheds, Burleigh Brewing, White Rabbit and Modus Operandi Brewing.

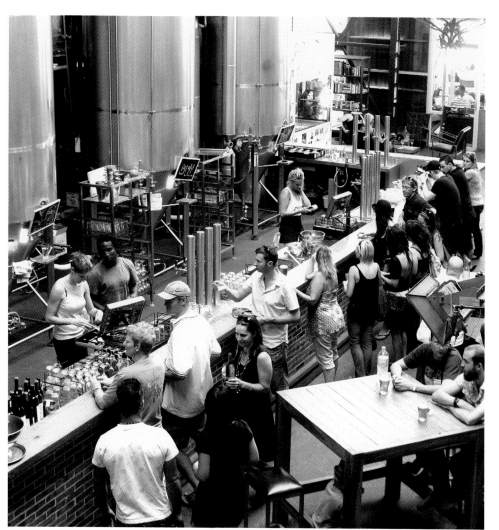

Left: Craft beers and food are served in microbreweries, such as Little Creatures Brewery in Fremantle, Western Australia.

Opposite top: Innovative wining and dining experiences are possible at wineries, such as the wine cave in Maxwell Wines, McLaren Vale, South Australia.

Opposite below: Australian-made whiskies, as made in Tasmania's Hellyers Road for example, compete successfully with the world's finest.

Natural Habitats

Some 220 million years ago Australia was part of Gondwana, an ancient supercontinent that also included India, Madagascar, Africa, South America and Antarctica. Australia drifted northwards and became drier and warmer, which meant that the plants and animals had to adapt to survive under the new climatic regimes.

Below: Flinders Ranges, South Australia's largest mountain range, forms a dramatic landscape.

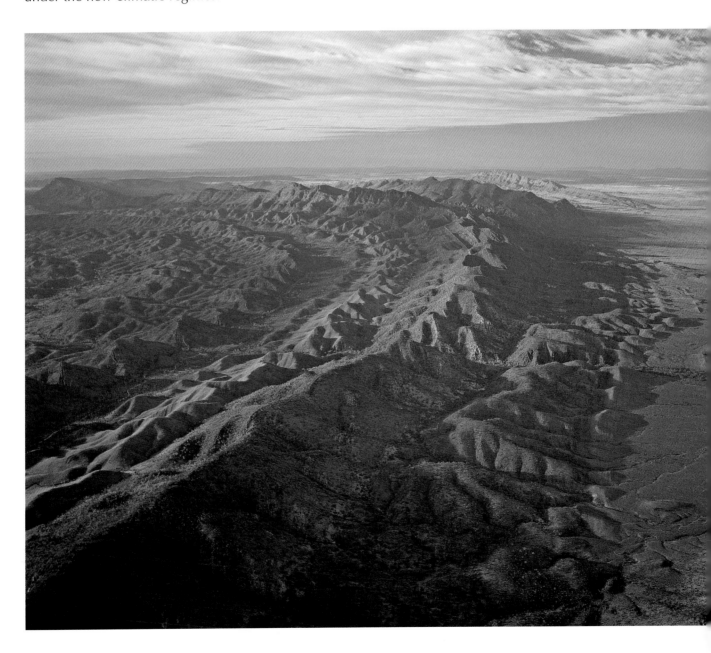

Once an island, Australian flora and fauna evolved in isolation making them unique in the natural world. When James Cook sighted Australia in 1770 on his journey of discovery, his botanist, Joseph Banks, collected thousands of plant species and, in so doing, increased the world's botanical knowledge by some 25 per cent. Botanists believe that 87 per cent of Australia's plants grow nowhere else on earth (this equates to 12,000 plant species). The south-west of Western Australia is further isolated due to the fact that it is bordered by oceans and deserts. This part of Australia is a refuge for ancient species and is known as a hotspot for biodiversity; one of 34 biologically rich and diverse reservoirs in the world. However, Australia's natural habitats have been drastically modified due to the accidental (and in some cases planned) introduction of plant and animal pests, many of which now dominate native species, as they have few natural predators.

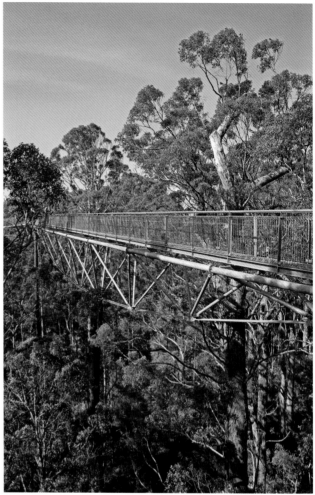

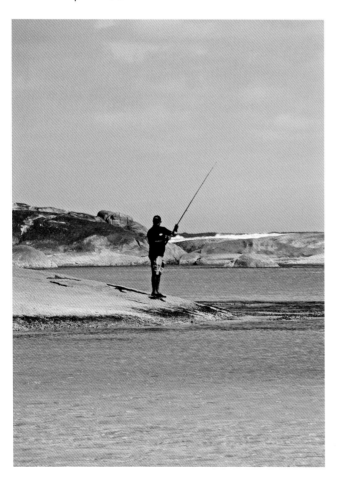

Australia is home to possibly the world's greatest habitat diversity that ranges from lush tropical rainforests in Queensland to the most inhospitable and barren desserts in the Northern Territory. Some 11.5 per cent of its land surface is protected as national parks or reserves and there are another 200 protected marine areas. The Great Barrier Reef situated off the north-east coast is the largest living form on earth and Uluru (Ayers Rock) in the Northern Territory is the world's largest monolith with a circumference of 9.4 km (5¾ miles).

Left: Greens Pool between Denmark and Walpole in Western Australia is one of Australia's most picturesque beaches.

Above: The Valley of the Giants in Western Australia's south-west traverses a eucalyptus forest of Giant Tingle Trees (Eucalyptus jacksonii).

The Great Barrier Reef and the Wet Tropics of Queensland are two adjoining UNESCO World Heritage Sites. The reef covers 280,000 sq km (108,111 sq miles), stretches 1,931 km (1,200 miles) north to south and supports 1,500 fish species, 400 corals and some 4,000 types of mollusc. There are 3,400 separate reefs and over 600 islands. Scientists suggest that 80 per cent of the marine species found in the southern waters below Australia are endemic. The vegetation in the wet tropics and other areas of high rainfall is classified as rainforest and this includes tropical through to pockets of temperate rainforest in NSW, Victoria and Tasmania.

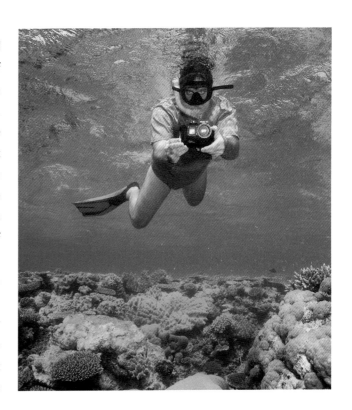

As a general rule, rainfall decreases with distance from the coast and the vegetation varies according to the rainfall and other climatic determinants. Woodlands (mallee or mulga) become savannah-like and then desert, as the rainfall decreases. Australia is the driest inhabited continent and its nutrient-poor soil means that only 6 per cent of the

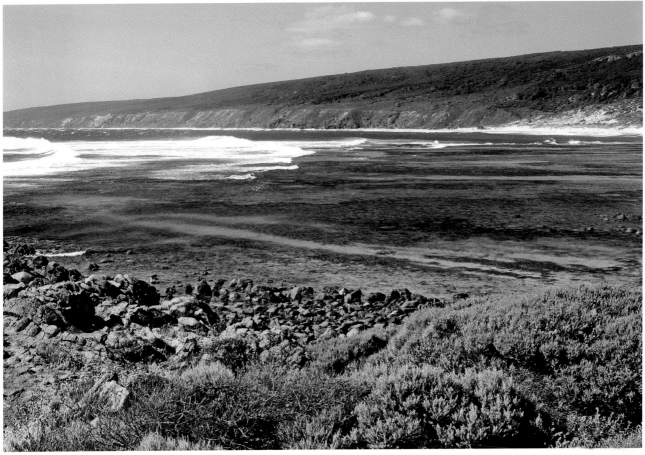

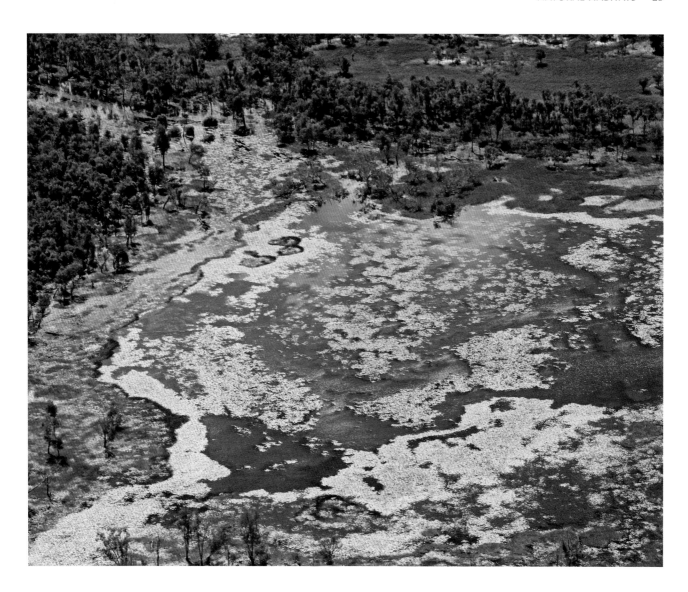

total land area is arable. The dominant type of vegetation in the country, covering some 23 per cent of the land surface is hummock grassland found in the arid areas of South Australia, the Northern Territory and Western Australia.

Wetlands are an important habitat and Australia has at least 65 Ramsar sites of ecological significance. These sites cover 7.5 million ha (18 million acres) and are valuable habitats for many reasons including as a refuge for some of Australia's 902 bird species and other migratory offshore birds. The Macquarie Marshes Nature Reserve is an important area of wetlands in central northern NSW. It is associated with the floodplain of the Macquarie River and varies in size depending on the available rainfall. Many

riverine areas of Australia support an iconic Australian tree, the River Red Gum. Alpine vegetation, such as Snow Gums, flourishes with altitude but above the snowline, vegetation becomes almost non-existent.

Above: Extensive tropical wetlands like those in Kakadu National Park attract visitors who come especially to see crocodiles.

Opposite top: The Great Barrier Reef is a prime location for divers and snorkellers.

Opposite below: Australia's long coastline provides many opportunities to surf off beaches like Yallingup, Western Australia.

Flora and Fauna

Australia's unique animals and plants make a valuable contribution to the nation's tourism. Kangaroos, Koalas, Emus, wombats and various species of wallaby are just some of the iconic menagerie that occurs nowhere else. But there many other, lesser-seen animals, such as the echidna, quoll, Numbat, dunnart, bandicoot, Tasmanian Devil, tree-kangaroo, Platypus and potoroo that make Australian fauna so remarkable. Most are marsupials, which means the females have pouches in which they carry and suckle their young. Monotremes (echidna and Platypus) are egg-laying marsupials that also suckle their young.

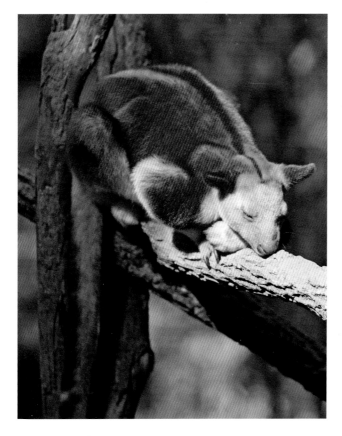

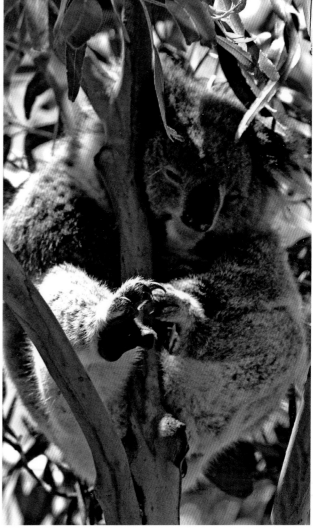

Above: The Tree-kangaroo inhabits the forests of north-east Queensland.

Right: Australia's Koala is not a bear but rather a marsupial that sleeps for most of the day.

While there are many dangerous terrestrial and marine organisms in Australia, they are rarely seen. Australia has some of the deadliest creatures on the planet of which the Taipan is the world's deadliest snake and the Sea Wasp (a species of box jellyfish) the most poisonous creature.

Whales were once hunted but now whale and dolphin watching is a tourist activity in most states with Humpback and Southern Right Whales, for example, being commonly sighted in south-west Western Australia (from June to December). Coastlines are also a habitat for various seal species. Kangaroo Island and Bruny Island are two locations with guaranteed sightings. Penguins can also be seen along the coasts and are a tourist attraction in places like Phillip Island, Kangaroo Island and Bicheno (north-east Tasmania).

Birds

Birds, too, are prolific with almost 902 species recorded as resident or migratory, 45 per cent of which are found nowhere else in the world. There are many bird species commonly seen including pelicans, Black Swans, Jabiru, various cockatoos, Satin Bowerbirds, Emus, Great Egrets, whistling ducks, cassowaries, various parrots, birds of prey and kookaburras.

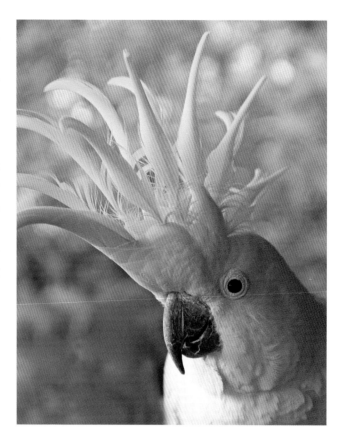

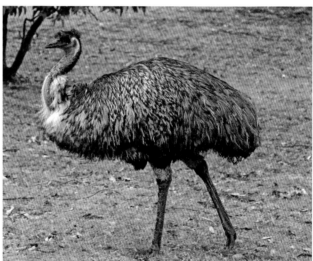

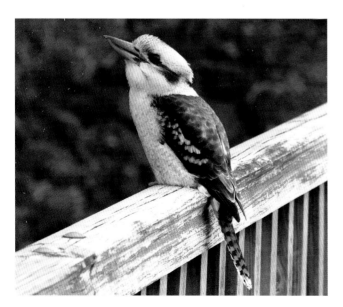

Left: Kookaburras are kingfishers with a raucous cackling call.

Above: The Emu is a flightless bird that is featured on the Australian coat-of-arms.

Top: The Sulphur-crested Cockatoo with its distinctive yellow crest.

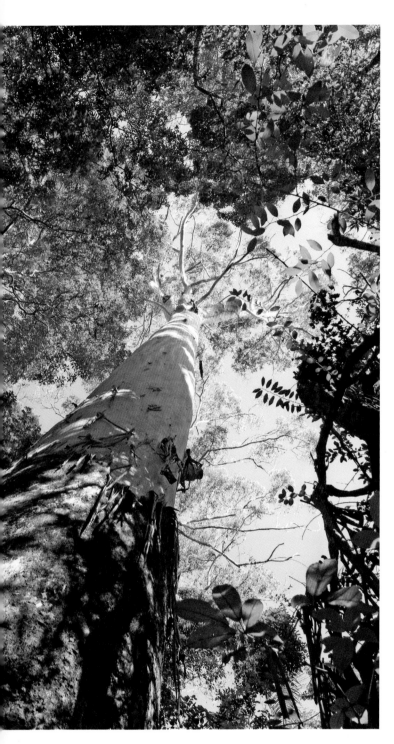

Plants

Of all the Australian plant species, the most common are from the Acacia, Eucalyptus, Melaleuca, Grevillea and Allocasuarina genera. There are 700 species of eucalypt for example, and one of them, the Mountain Ash, is the second highest tree in the world after the Californian Redwood. Eucalypts, such as Snow Gums and various mallees, grow in a range of habitats from snow-capped peaks to parched desert plains. They are hardwoods and in Western Australia the Red Tingle, Jarrah and Karri grow prolifically in the south-west of the state. This part of the state is an important biological zone in that it supports 12,000 different plant species, almost 90 per cent of which are endemic.

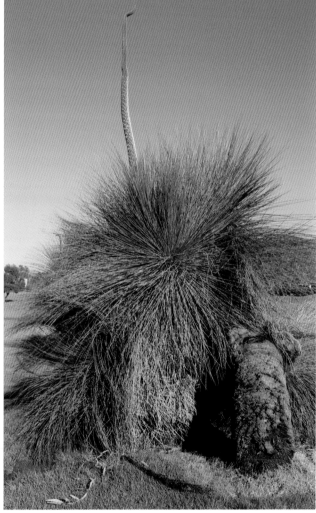

Above: Some species of eucalypt trees grow to a height exceeding 80 m (262 ft).

Right: Grass trees grow very slowly and have a distinctive flowering spike rising from the top of the tall plant.

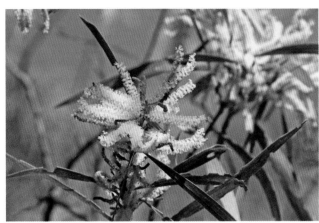

There are many distinctive Australian flowers, such as wattles, banksias, hakeas and bottlebrushes, as well as those of the various eucalypts. There are some 950 species of wattle for example, with the Golden Wattle (*Acacia pycnantha*) being the national flower.

One of the most unusual flowers is the kangaroo paw, which is a common name for a variety of species belonging to two genera (*Anigozanthos* and *Macropidia*) of the Haemodoraceae family. These perennials are bird-attracting flowers, which are endemic to the south-west of Western Australia and resemble the paw of a kangaroo, albeit a small one. The Red and Green Kangaroo Paw (*Anigozanthos manglesii*) is the state flower of Western Australia.

New species of plant are constantly being discovered, like the *Thismia megalongensis*, a rainforest flower with a distinctive smell of rotting fish.

Left: The wattle is Australia's national flower.

Below: While endemic to Australia, bottlebrush shrubs are planted in many parts of the world.

Bottom left: The flowers of the kangaroo paw resemble those of the animal.

Bottom right: The 170 species of banksia belong to the Proteaceae family.

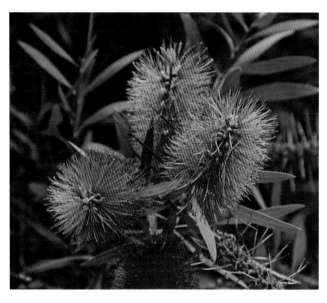

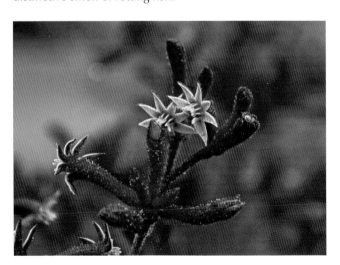

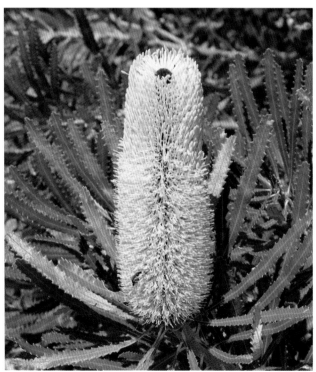

Arts and Culture

All Australian capital cities have art galleries plus theatre and concert halls for the performing arts, which are regularly staged. Performance spaces include famous locations, such as the Sydney Opera House, Melbourne's Princess Theatre and the Theatre Royal in Hobart, Australia's oldest continually operating theatre. Many regional cities and towns, such as Ballarat and Dubbo, also have well-attended theatres.

The National Gallery Canberra has the world's largest collection of Australian indigenous art including the acclaimed works by Albert Namatjira and early Papunya dot paintings. Nearby, the Gallery of Australian Design showcases design and its contribution to the national identity.

In Sydney, the Art Gallery of NSW has several galleries devoted to specific collections including Australian, European, Asian, contemporary art and photography.

GOMA at South Bank in Brisbane is part of the Queensland Cultural Centre and is Australia's largest gallery

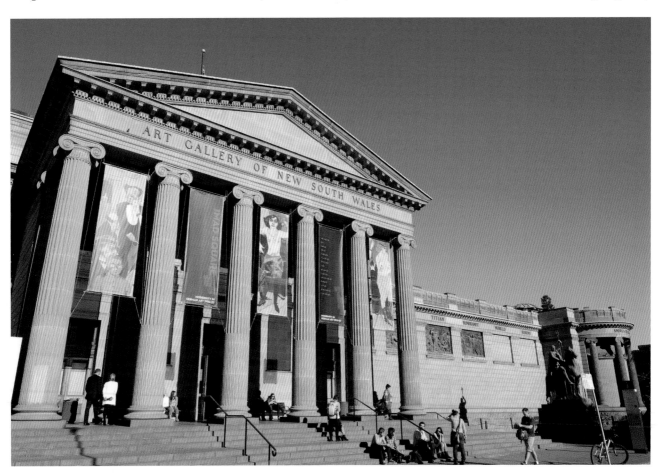

of modern and contemporary art. In Hobart, the privately-funded MONA houses an amazing collection of new and old art. Its cliff-side location overlooking the harbour plus its lifestyle facilities and landmark architecture have made it an integrated destination and, even in its short history, one of the world's most talked-about art museums.

Professional theatre companies have nurtured many famous Australian actors who have helped put the nation in the focus of global audiences. While some movies have portrayed the landscape, pioneering spirit or uniquely Australian traits, others have been more universal in their subject matter. Warner Bros Movie World theme park on the Gold Coast includes several fully operational film studios where globally successful movies have been produced. Fox Studios Australia in Sydney is also a centre for movie and television production.

What started as a showcase for short films in Sydney's Tropicana Café has evolved into Tropfest, the world's most acclaimed short-film festival that is now screened in many cities. There are also many arts festivals in Australia with the Adelaide Festival and Fringe Festival being two of the most acclaimed.

Australian materials are used extensively in the craft and jewellery industries with wool, opals, glass and native timbers all being skilfully crafted and highly prized.

Left: The National Gallery of Victoria showcases respected local and international artists.

Opposite: The Art Gallery of NSW is home to the Archibald Prize portrait art competition.

Above: Hobart's acclaimed Museum of Old and New Art (MONA) includes an area for outdoor sculptures.

Sports and Lifestyle

Australians are passionate about their sport and idolize local sporting heroes. The nation's sporting prowess is to many as important as its economic statistics or any other measure of well-being. Australians feel good when the nation's sporting heroes succeed on the world's playing fields, which they do with great regularity. For a nation with a small population, it does disproportionately well across a whole range of sports even including the Winter Olympics.

Opposite top: The Melbourne Cup horse race in Victoria.

Opposite below: Bushwalking trails like the Cape to Cape in Western Australia pass through scenic landscapes.

Below: The hallowed Melbourne Cricket Ground also hosts Aussie Rules football matches.

In addition to established global sports, such as football, rugby, cricket, cycling and swimming, Australian Rules Football and touch football are local sports that are also popular. Netball has one of the highest participation rates of all sports while fishing is an important recreational activity. Despite efforts to spread various sports nationally, there is still a tendency for Aussie Rules to be a Victorian, South Australian and Western Australian sport while rugby league and rugby union dominate in NSW and Queensland. Football (soccer) is the most universally played. The national sporting teams include the Wallabies (rugby), Kangaroos (rugby league), Socceroos (soccer), Boomers (men's basketball), Opals (women's basketball), Kookaburras (men's hockey) and Hockeyroos (women's hockey).

At 3 o'clock on the first Tuesday in November, the Melbourne Cup, the world's richest 3,281-m (2-mile) horse race, is an event that stops the nation. First staged in 1861, this day is celebrated as a public holiday in Victoria, though very little work is done in most other states during the race.

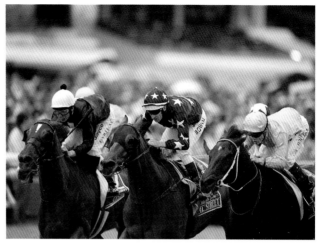

With its extensive coastline, it's not surprising that watersports, such as surfing, swimming, sailing and stand-up paddle boarding, have big followings. Many beaches are patrolled by volunteer lifesavers dressed in their unique red-and-gold caps.

Australia has hosted two Olympic Games (Melbourne in 1956 and Sydney in 2000). Sydney, Perth, Brisbane, Melbourne and the Gold Coast are also Commonwealth Games host cities. Melbourne annually hosts the Australian Open – the fourth of the Grand Slam tennis tournaments.

The Australian lifestyle is generally relaxed and casual where most sporting and recreational activities are conducted outdoors due to the favourable climate. Many Australians get involved in activities, such as picnics, barbecues, bushwalking, jogging, swimming, camping and cycling for recreation. Australia has several great walks including the Bay of Fires, Maria Island Walk, Cradle Huts and Freycinet in Tasmania plus the Great Ocean Walk (Victoria), the Arkaba Walk (SA), the Larapinta Trail (Northern Territory) and the Cape to Cape Walk (WA).

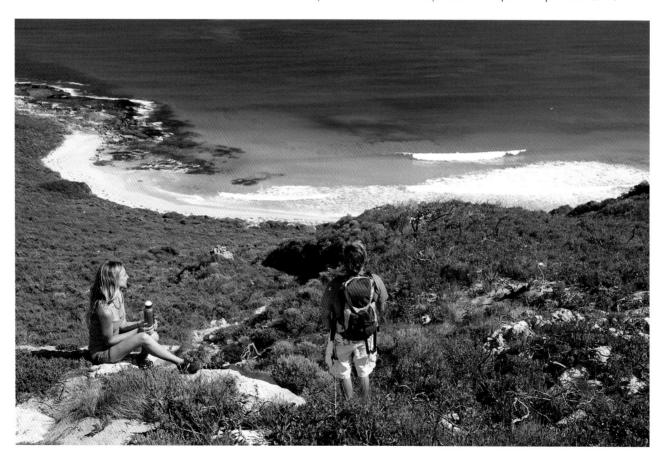

Chapter 2: Canberra and the Australian Federal Territory

Three hours' drive south-west of Sydney, the federal capital of Canberra is a planned city centred on Lake Burley Griffin and surrounded by the Tidbinbilla Hills. Originally part of NSW, planning for the development of Canberra and the Australian Capital Territory (ACT), started in 1911.

Canberra has been described as a vast parkland with the occasional building so there are many green areas, cycling paths, sporting parks, picnic areas and trails for recreation.

Being the base for overseas missions in Australia and a university city, there is a smorgasbord of dining opportunities and several wineries are located near the city and in neighbouring NSW.

The National Botanic Gardens are dedicated to native flora and display some 6,000 native Australian plants. They are arranged in different environments including a rainforest, rock garden and eucalyptus lawn. In September, the Floriade Festival is a celebration of spring and the flowers that bloom then.

Right: Canberra is home to the Australian Institute of Sport (AIS), Australia's strategic, high-performance sports academy. Other attractions in the city include Questacon at the National Science and Technology Centre (a hands-on science learning centre that especially appeals to families), Screen Sound Australia (an archival collection of the nation's film and sound recordings), the National Library of Australia, the Royal Australian Mint (where the nation's currency is produced), the National Portrait Gallery and Telstra Tower (highlighting the history of telecommunications).

Left: It's a city of extensive parklands and lakes that were designed by American architect, Walter Burley Griffin (the main lake is named after him). The city's success and beauty can be attributed to the vision of the plan and those who implemented it over the decades. It covers an extensive area of vegetated land and large traffic roundabouts add to its spaciousness.

Below left: There are several attractions and buildings that represent the aspirations of the young nation. The current Parliament House built in 1988 features an interior of Australian timbers, which visitors can admire on a free guided tour. Close by, the National Gallery of Australia houses a world-class collection of art with an impressive display of Aboriginal and Torres Strait Islander paintings.

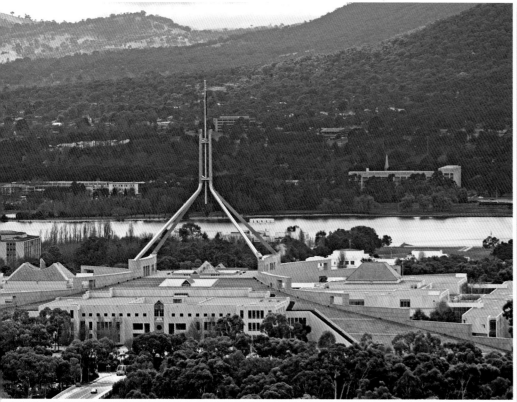

Chapter 3: Sydney and New South Wales

S ydney is Australia's first and largest city and is the capital of New South Wales (NSW). Its spectacular harbour and landmark architecture were showcased to global viewing audiences during the Olympic Games, which were staged in 2000. Visitors also travel to Sydney to enjoy the beaches, harbour, fabulous food and welcoming Sydneysiders. Sydney Fish Market is reputedly the world's second largest fish market where fresh seafood is sold to be served in restaurants and cafés. There are other markets in the inner city the best known being the Farmers' Market at Fox Studio, Paddington, Glebe and Paddy's Market in Chinatown. Food precincts like Crown Street (Surry Hills), Norton Street (Leichardt), King Street (Newtown), Glebe Point Road (Glebe), Campbell Parade (Bondi) and Chinatown all attract eager diners.

Sydney

Right and opposite top: Two iconic structures dominate the harbour – the famous Sydney Opera House designed by Danish architect, Jørn Utzon, is adjacent to its equally famous neighbour, the Sydney Harbour Bridge spanning 503 m (1,650 feet). Both are impressive architectural landmarks with the 'sails' of the former representing sections of a sphere. Visitors can walk, cycle, drive or catch the train across the bridge, although climbing the bridge span is the most adventurous way of getting from one side to the other.

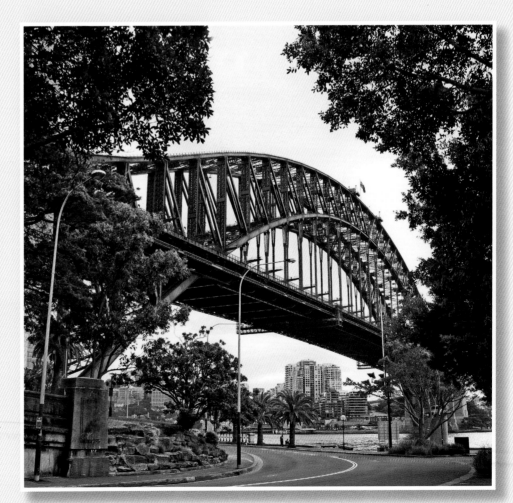

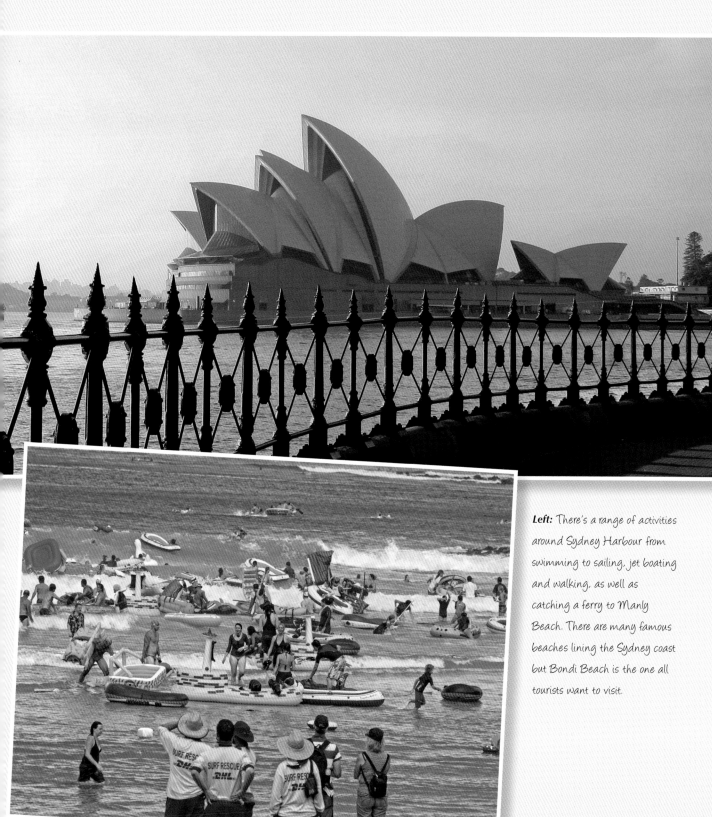

Left: There's a range of activities around Sydney Harbour from swimming to sailing, jet boating and walking, as well as catching a ferry to Manly Beach. There are many famous beaches lining the Sydney coast but Bondi Beach is the one all tourists want to visit.

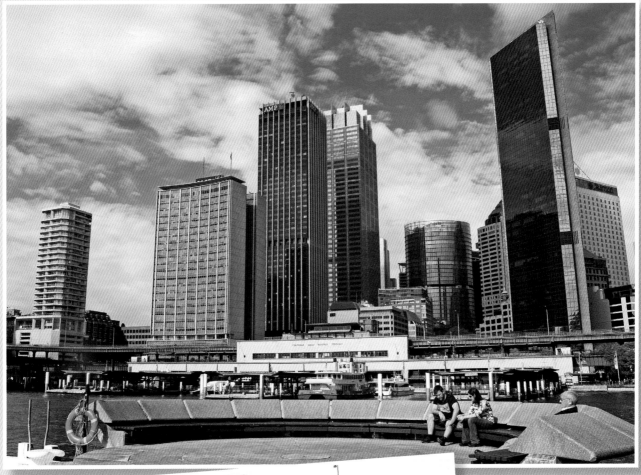

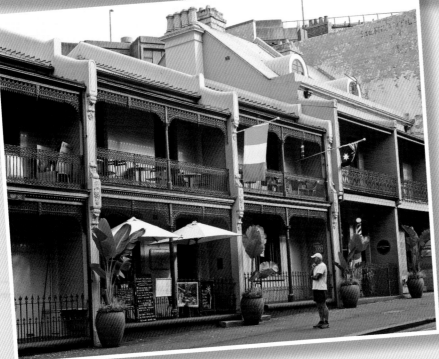

Above: There are many city attractions including Taronga Zoo, the Art Gallery of NSW, the Powerhouse Museum, the Botanic Gardens, Darling Harbour and a walk around Circular Quay (pictured). The Explorer Bus provides access to the main sights.

Left: Parts of historic Sydney remain in an area called The Rocks, which is adjacent to Circular Quay where the first European settlement was established.

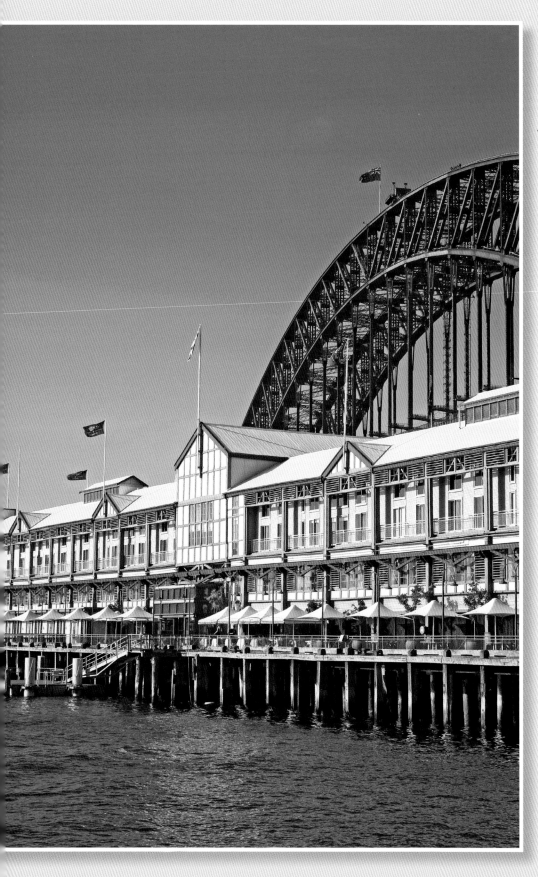

Left: Pier One in Dawes Point on Walsh Bay is the closest finger jetty to the Sydney Harbour Bridge. This and other jetties in the harbour are an integral part of Australia's history as they were used to export Australian produce overseas; troops departed from here for various wars and migrants disembarked here after their overseas journeys. The P & O Company used Pier One to berth its ocean liners until 1963. The pier is now occupied by a luxury hotel with prime waterfront views.

Northern NSW

Sydneysiders escape the city for weekend breaks on the Hawkesbury River, the Blue Mountains, the Southern Highlands, Central Coast or the Hunter Valley. The Blue Mountains are a natural wonderland of wilderness forests and dramatic sandstone formations. Katoomba is the main town but there are several quaint villages such as Leura, Blackheath and Wentworth Falls to add to the holiday ambience. Waterfalls, Jamison and Megalong Valleys and the Three Sisters at Echo are natural features of this World Heritage Area covering a million hectares (3,861 sq miles). Trails follow the escarpment or cross the valleys, while the Scenic Railway provides alternate access to the valley.

Opposite top: The coastal strip along the Pacific Ocean north to the Queensland border is dotted with resort towns, quiet fishing villages, eco escapes and family attractions but mostly on a small and leisurely scale. The main resort towns from the south to the north are Forster, Port Macquarie, Nambucca Heads, Corindi Beach (pictured), Coffs Harbour, Ballina and Tweed Heads.

Below: The Great Dividing Range that runs along the easternmost parts of NSW includes many wilderness areas and national parks, such as Wollemi, Barrington Tops, Dorrigo and New England.

Opposite below left: Byron Bay Lighthouse in northern NSW is the easternmost point on the Australian mainland.

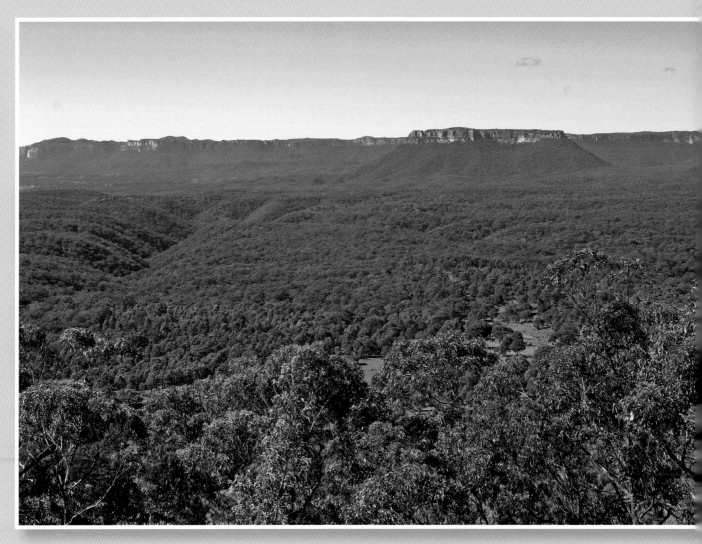

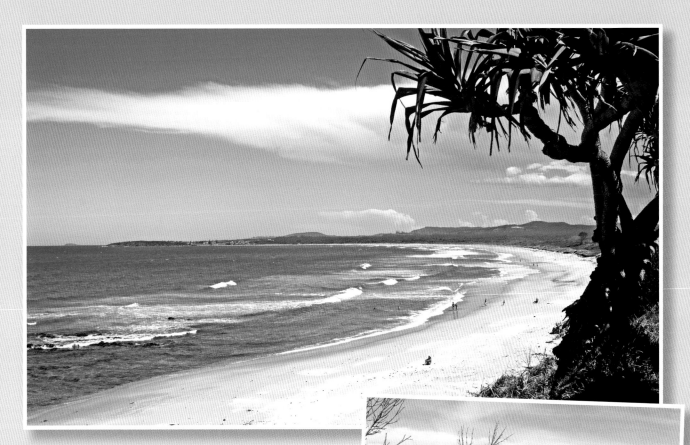

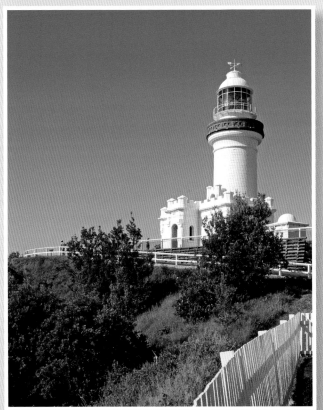

Above: Now a tourism hub, the Hunter Valley offers many attractions including fine wines (especially Semillon and Shiraz), the meticulously planned Hunter Valley Gardens (pictured), restaurants, spas, hot-air ballooning, resorts and golf courses. Newcastle, on the Hunter River about 118 km (73 miles) north of Sydney, is the state's second largest city renowned for its beaches, surf and emerging art community.

Right: Port Stephens just north of Newcastle appeals for its near-deserted beaches and protected bay. Bottlenose Dolphins can be seen in the tranquil waters and holidaymakers enjoy a variety of watersports, golf courses, sand safaris amongst rolling dunes, sailing and fresh seafood in bayside settings.

Below: Byron Bay and Bangalow (pictured) are located near the far northern coast of NSW with the former being the easternmost point of the Australian mainland. Both have a reputation for alternate living but Byron Bay's beautiful beaches have universal appeal. There are several old farming districts, which are also home to those seeking an alternate lifestyle with Bellingen and Nimbin being fascinating counter-culture tourist towns.

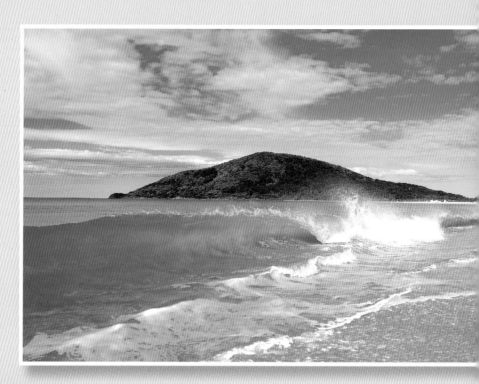

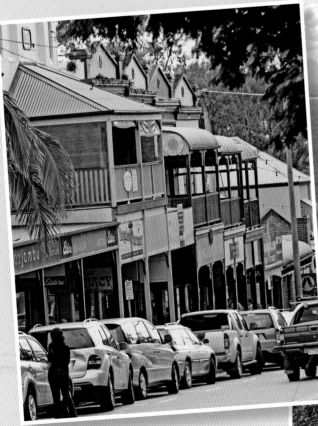

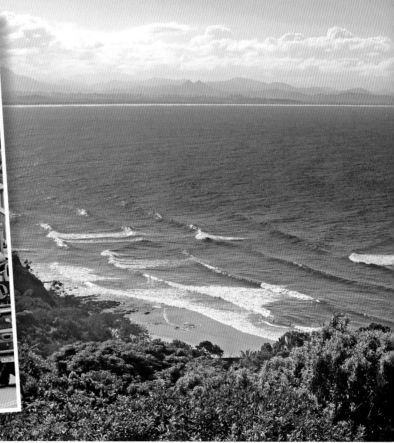

Southern and Western NSW

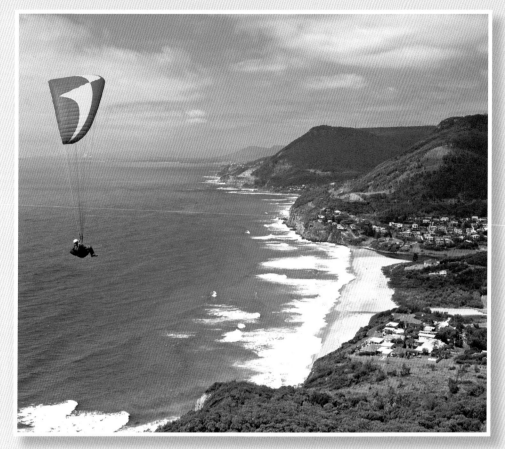

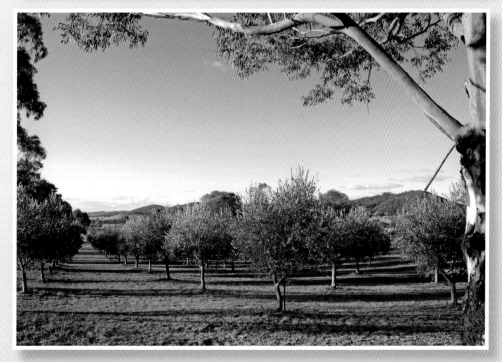

Left: South of Sydney, the south coast has some brilliant scenery with Jervis Bay and Hyams Beach having the world's whitest sands. Bald Hill, north of Wollongong, is a major paragliding and hang-gliding site. Life in the seaside towns of Nowra, Batemans Bay and Merimbula moves at an unhurried pace, which makes them popular for family holidays. Further west, the towns are few and far between and beyond the vast wheat and sheep farms, it's the 'outback' and ultimately desert. Orange, Broken Hill, White Cliffs and Lightning Ridge are country towns that offer real Aussie bush hospitality. Visit Tamworth in late January for the famous Country Music Festival.

Below left: There are many country towns on the western side of the Great Dividing Range which runs down much of the east coast. Mudgee is a wine town just four hours' drive from Sydney and its fine wines, trendy cafés, restaurants and boutique accommodation make it a popular weekend escape.

Chapter 4: Melbourne and Victoria

Melbourne, the Victorian capital, is a city with a very gracious European-styled central business district. The city evokes comparisons with Europe in its climate, architecture and style and is often voted as the world's most livable city. It is Australia's second largest city after Sydney and the headquarters for many Australian companies. Melbourne is ranked Australia's fashion capital and also a centre for culture such as food, theatre and entertainment in venues like the Crown Entertainment Complex and the historic Princess Theatre.

Below: As a city, Melbourne has many personalities from its back streets and laneways to the vastness of the suburbs as viewed from vantage points like level 55 of Rialto's Observation Deck or the Eureka Skydeck 88 (pictured) where 'The Edge' or glass cube protruding into space provides a nail-biting experience.

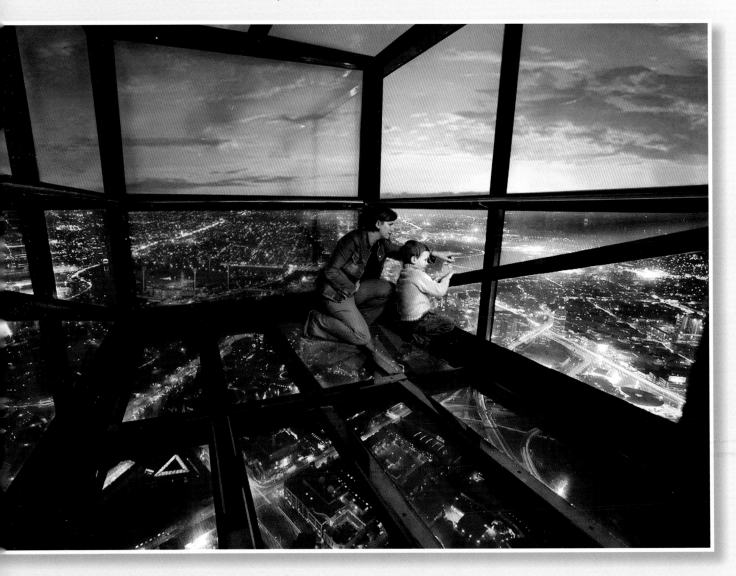

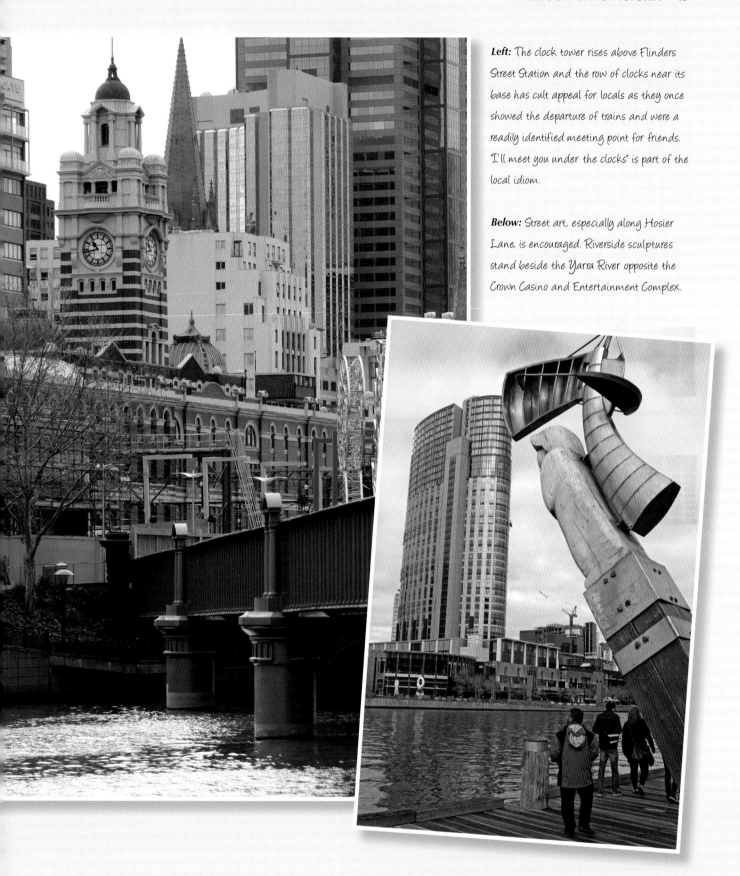

Left: The clock tower rises above Flinders Street Station and the row of clocks near its base has cult appeal for locals as they once showed the departure of trains and were a readily identified meeting point for friends. 'I'll meet you under the clocks' is part of the local idiom.

Below: Street art, especially along Hosier Lane, is encouraged. Riverside sculptures stand beside the Yarra River opposite the Crown Casino and Entertainment Complex.

Right: Trams add to Melbourne's charm. The free City Circle Tram enables easy access to most city attractions.

Below: The Royal Exhibition Building adjacent to the Melbourne Museum. Melbourne is well known for its galleries and museums such as the Immigration Museum, which explores real-life stories of the many people who migrated to Australia. The Arts Centre Melbourne is home to the performing arts, while the Ian Potter Centre at the National Gallery of Victoria has an extensive collection of Australian paintings.

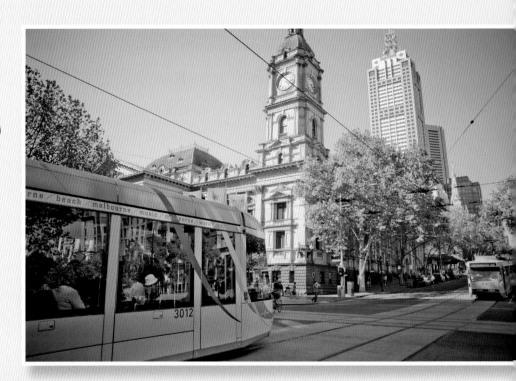

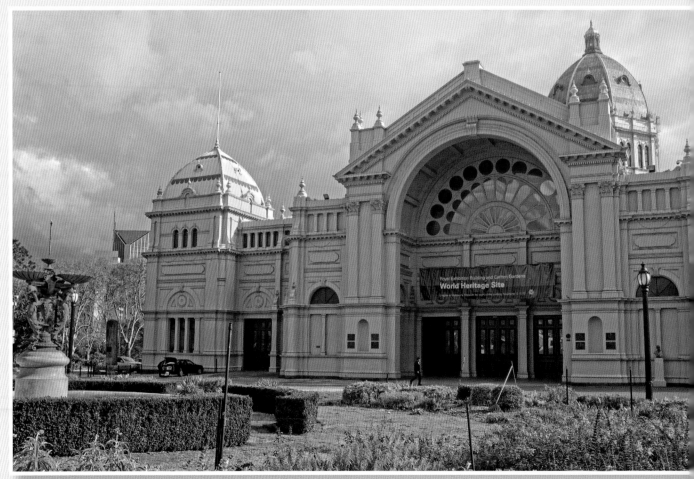

Left: Melbourne is considered more European in its architecture than Sydney. Many old stone buildings have been preserved in the city centre but new ones are also being incorporated into the streetscapes of many of the central thoroughfares.

Below: Australian multiculturalism ensures that visitors can dine around the world in Melbourne. The people of Melbourne love to eat and cook; Queen Victoria Market is one of the best sources of the freshest ingredients. This is a dream destination for epicureans especially as the markets are open most days of the week. There are many food precincts such as Brunswick Street, Acland Street, Chinatown, Southbank, Docklands, Lygon Street (Italian) and Victoria Street (Vietnamese). The Melbourne Food and Wine Festival in April is the time to visit to enjoy the best that the city has to offer.

Beyond Melbourne

Melbourne's notorious 'four seasons in one day' weather may explain why the people of Melbourne are more interested in food, coffee and wine which, in winter, are consumed indoors like they are in most European cities. In summer though, the beaches on Port Phillip Bay, such as St Kilda and Brighton Beach, are as crowded as they are in other parts of Australia. Mornington Peninsula located on the eastern side of the bay is home to estates famous for their cool climate wines as well as golf courses, walking trails and historic bayside villages like Portsea.

The Yarra River that flows through Melbourne has its source in the Yarra Valley, home to Australia's finest cool climate wines. Boutique accommodation, produce stalls and restaurants add to the valley's appeal.

Below left: Sam Miranda Wines are produced in the small rural district of Milawa within the King Valley in northern Victoria. Sam Miranda is a third-generation Australian whose forefathers emigrated from Italy and brought with them intimate wine-making skills. As a tribute to his Italian heritage, Sam Miranda is part of the Prosecco Road, along with other winemakers in the district who produce Australian-styled, Italian Prosecco. Other wine tourism districts in the state include Rutherglen, Beechworth, Pyrenees, King Valley, Geelong and Macedon Ranges.

Above: Yering Station is one of Yarra Valley's premium wine producers and Victoria's oldest winery. It is renowned for sparkling wines plus its Chardonnays and Pinot Noirs. It makes sparkling wines in association with Champagne Devaux. It is a destination winery with sculptures in the garden, a local produce store, a wine bar and a restaurant.

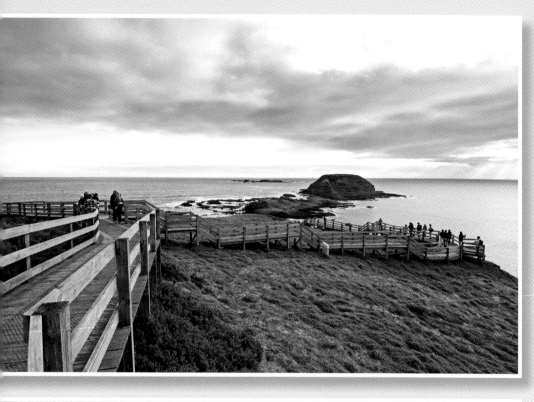

Left: Phillip Island, 90 minutes to the south-east of Melbourne, is home to the Grand Prix motorcycle track and natural habitats where Fairy Penguins appear on the sands each evening. Mornington Peninsula to the south of the capital has many seaside villages lining the bayside with Portsea being the most fashionable and affluent destination. Golf courses, wineries and walking trails add to the peninsula's charm.

Below left: Victoria's High Country includes the premier ski fields of Mount Hotham, Mount Buller and Falls Creek. On-snow facilities and accommodation are well developed and when the snow melts in summer, the region attracts bushwalkers. Gateway towns to the High Country are also favourite destinations for holidaymakers; the towns of Bright and Mount Beauty being most spectacular with the autumnal hues of their vegetation.

These pages: One of Australia's most spectacular road journeys is the Great Ocean Road, which follows the southern coast from Torquay, Warrnambool and on to Mount Gambier and Adelaide in South Australia. The route traverses one of Australia's iconic coastal landmarks known as the 12 Apostles plus rugged coastal formations and quaint coastal towns.

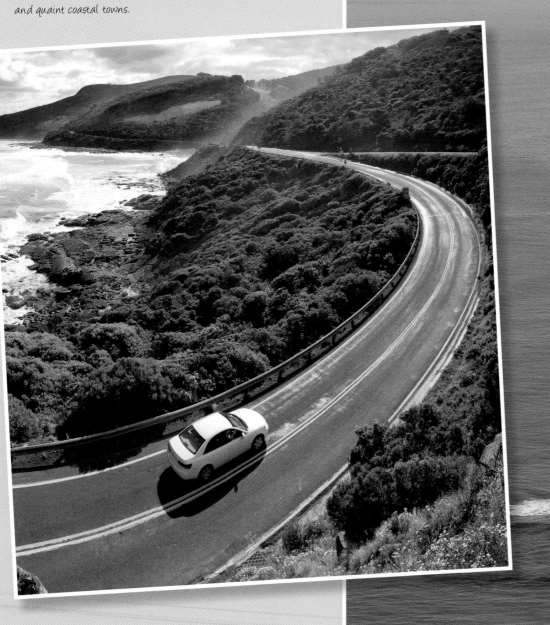

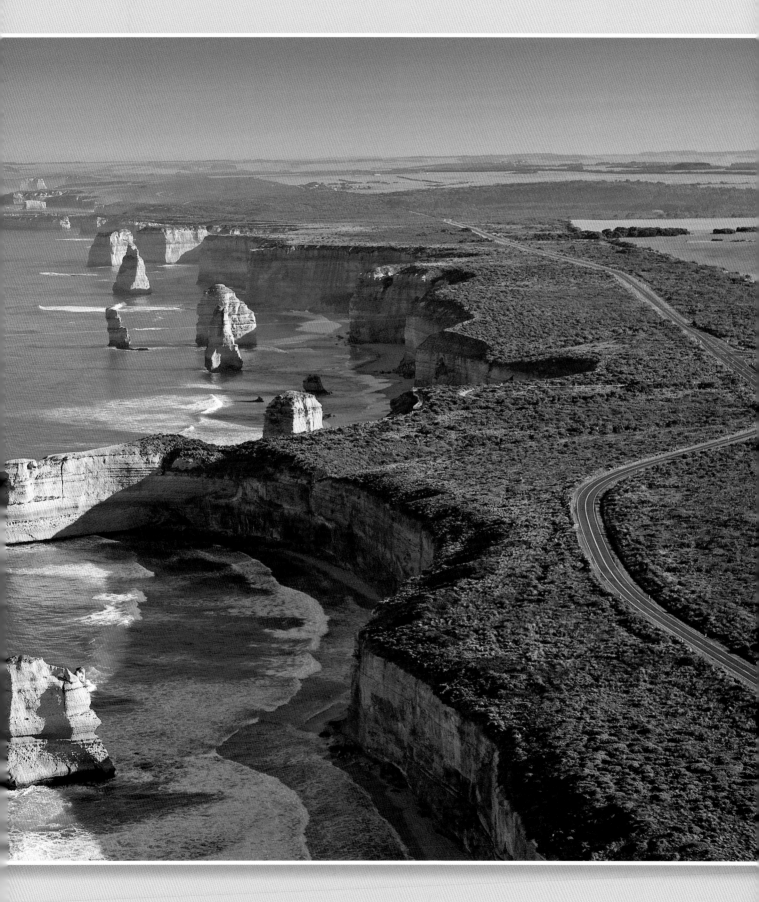

Chapter 5: Adelaide and South Australia

South Australia is the only state that was not settled by convicts. From 1836 onwards, free settlers emigrated mostly from Britain and bought land here. Adelaide, the state's capital city is a planned urban area with spacious parklands, the Mount Lofty Range as a backdrop and the Gulf of St Vincent along the western seaboard.

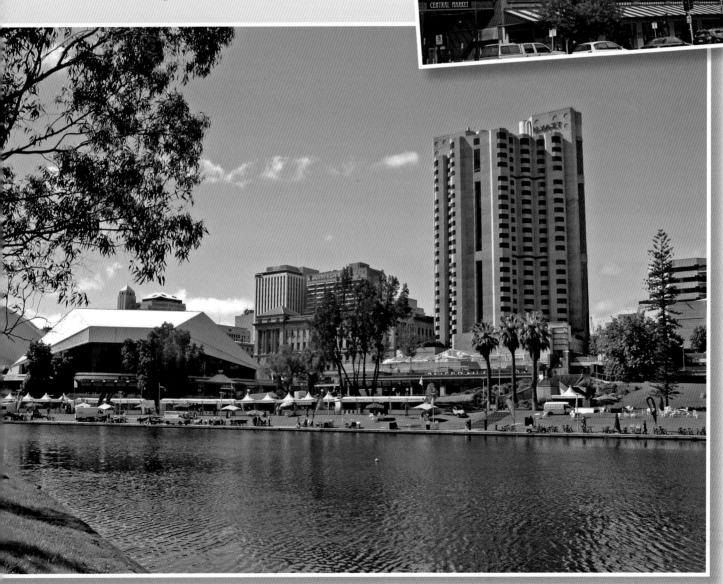

Opposite top: *Rundle Street Mall and Central Market are two of the most exciting shopping venues in the city. The former is a pedestrian precinct lined with boutiques and department stores, while Central Market is one of Australia's most famous fresh produce markets. Central Market is brimming with local fruit and vegetables as well as hard-to-get items from around the globe. It is frequented by locals who often start their shopping with a shot of coffee, then stock up on the most delicious treats. Food precincts in the city include Gouger Street, Rundle Street, O'Connell Street in North Adelaide and Unley Road.*

Left and opposite below: *The Torrens River meanders through the downtown area and its adjoining tree-lined parks create a wonderful sense of space. The Botanical Gardens, Adelaide Zoo, the Adelaide Cricket Ground and a golf course are part of the parklands that make Adelaide a wonderful walking city. Trams provide access to many attractions in central Adelaide.*

Beyond the City Limits

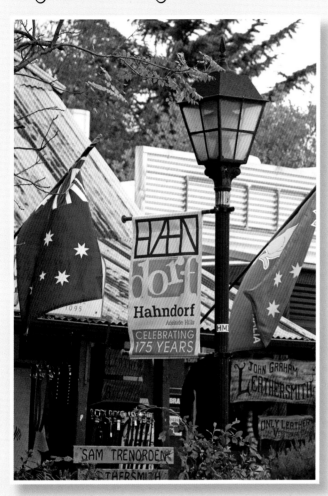

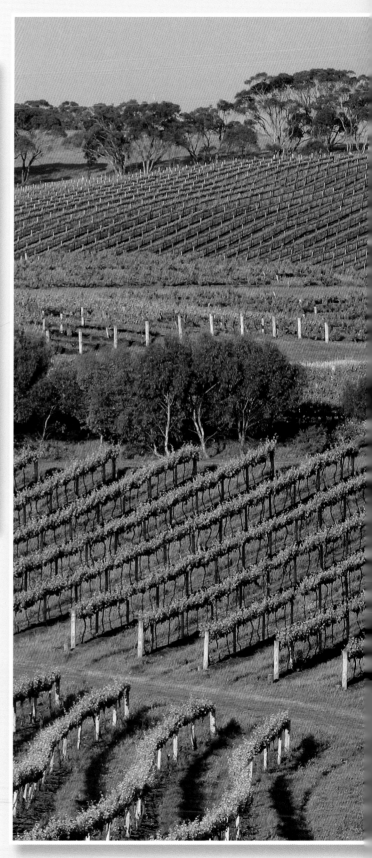

Above: Australia's multiculturalism is reflected in townships like Hahndorf. Stop at Mount Lofty on the way to get an elevated view of Adelaide, Australia's fifth biggest city. Hahndorf retains many characteristics inherited from early settlers from Germany, especially the food. Visitors can enjoy sausages, sauerkraut and pork knuckle over a stein of beer just as they might at the Munich Oktoberfest.

Right and opposite page: South Australia is the country's most famous wine state where grapevines even thrive at the famous suburban Penfolds Magill Estate (opposite top and centre). German immigrants started making wine in the Barossa Valley and sixth-generation descendants continue these traditions. Wineries are also located in the Clare Valley (right and far right), Adelaide Hills, McLaren Vale and Coonawarra.

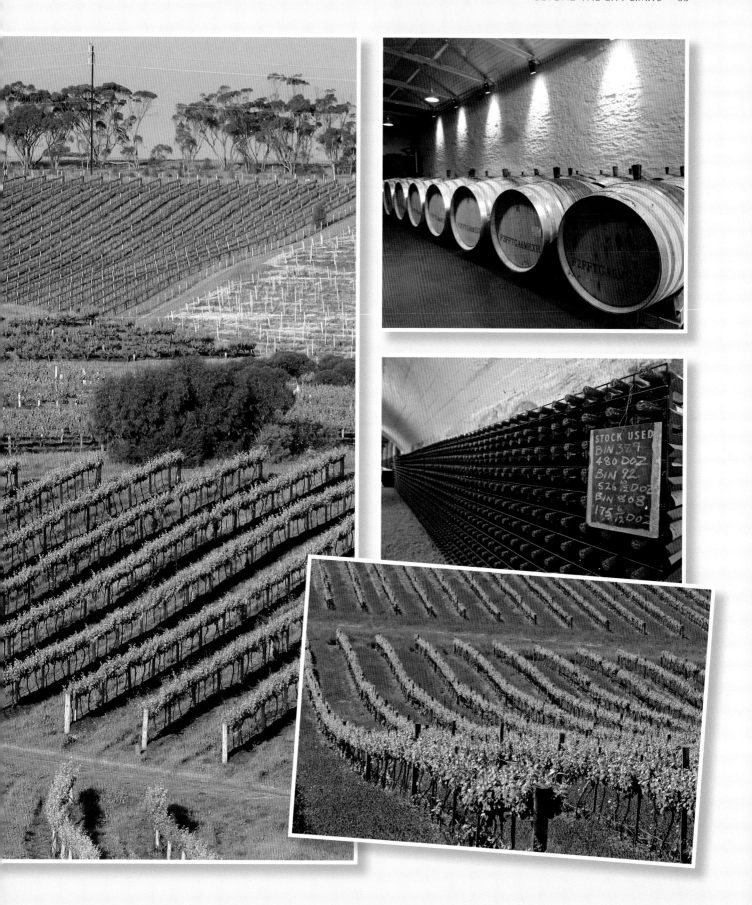

Kangaroo Island

Right: The beachfront of Seal Bay Conservation Park is where Australian Sea Lions relax in the sun and where tourists can get quite close to these wild animals.

Below: While it's possible to fly from Adelaide to Kangaroo Island, there is a vehicular ferry that operates from Cape Jervis on the mainland to Penneshaw on the island. Australia's third largest island is sparsely settled and much of it is a nature refuge.

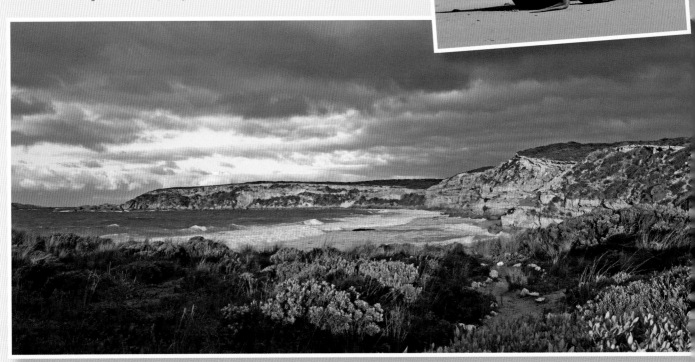

Left: Near-deserted roads provide access to the picturesque Remarkables Rocks and Vivonne Bay (pictured), rated one of Australia's best beaches. Kangaroo Island is known for its fresh seafood, such as lobster and abalone, as well as the freshwater crustacean, marron. Wine is produced in several wineries as are spirits at Kangaroo Island Spirits. Ligurian honey is another treat found only on Kangaroo Island.

Eyre Peninsula

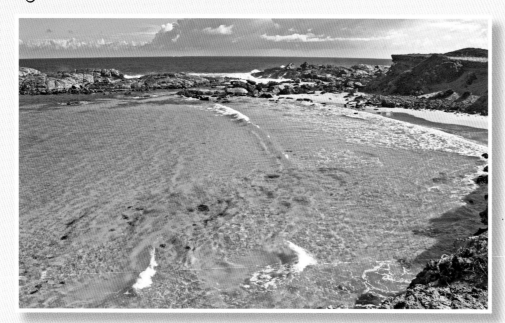

Left: Just off Port Lincoln on the Eyre Peninsula, it's possible to dive in a cage to see Great White Sharks. More sedentary visitors can relax and enjoy local wines and freshly shucked Coffin Bay oysters.

Flinders Ranges

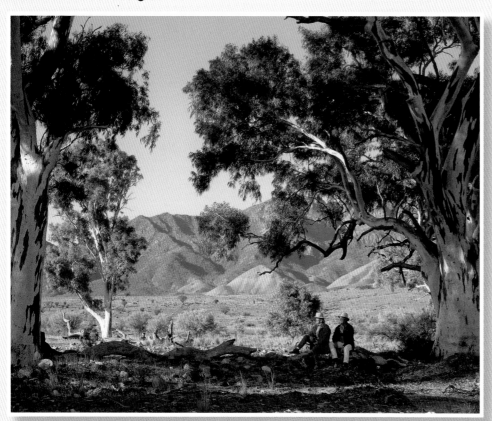

Left: The Flinders Ranges (pictured) is another starkly picturesque, natural area of mountains and ravines that is home to some iconic Australian animals. Wilpena Pound is an enormous, crater-shaped, natural amphitheatre in the Flinders. Coober Pedy, about half-way between Adelaide and Alice Springs in the Northern Territory, is an opal-mining settlement where the residents all live underground because of the heat. Day trips to the white salt pan of Lake Eyre are possible from Coober Pedy.

Chapter 6: Perth and Western Australia

Australia's largest state fronts the Indian and Southern Oceans with a coastline of some 12,889 km (8,009 miles). Western Australia's capital, Perth, is reputedly the most isolated city in the world (Perth is closer to Bali and Singapore than it is to Adelaide and Sydney). It is a large, modern city of 1.7 million residents with glistening skyscrapers overlooking the expansive Swan River which flows into the Indian Ocean near Fremantle (known as 'Freo'). Many of the state's mining companies are headquartered here and it is the state's rich mineral deposits that mostly fuel the economy.

Below: Perth has a vibrant nightlife plus cultural and entertainment scene. Crown Perth is a large casino and entertainment complex while Northbridge and the recently developed lanes and alleyways of the city are home to trendy bars and restaurants. Perth International Arts Festival (February to March) is a good time to experience the finest films, theatre and concerts.

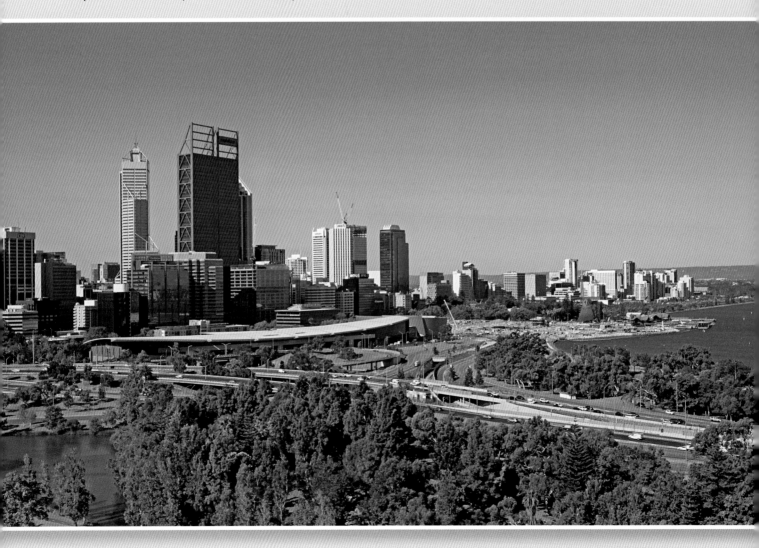

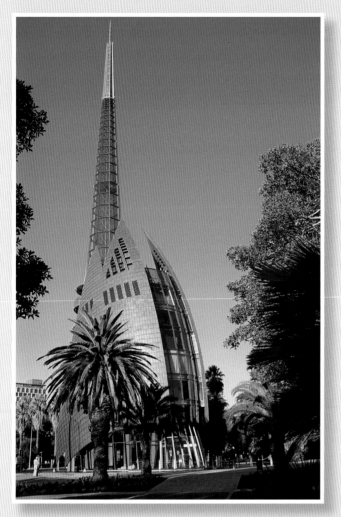

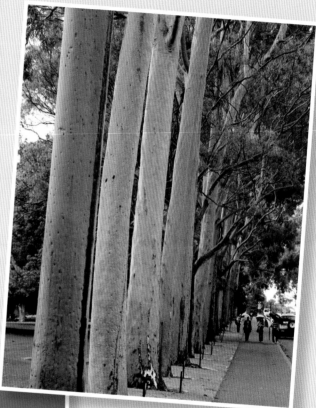

Left: The Bell Tower on Riverside Drive overlooking Swan River houses the Swan Bells. The 18 bells form one of the largest sets of change-ringing bells in the world.

Above: Adjacent to the city is Kings Park (pictured) and Botanic Garden, part recreational and part botanical with excellent native gardens. On the other side of the river, Perth Zoo houses many Australian animals while Caversham Wildlife Park, 30 minutes away, offers a similar experience. Perth is one of the world's great cities with a pleasant Mediterranean climate.

Left: Suburban Perth has many superb beaches including Cottesloe (pictured) and Scarborough.

Fremantle and beyond

Right: Fast boats operate from Perth to Fremantle and onto the beaches of Rottnest Island, one of several playgrounds for the locals. It was named by Dutch explorers to mean 'rat's nest' after the Quokka (a cat-sized marsupial resembling a minute kangaroo) that lives here. It is a popular recreation island with secluded beaches and bays plus cycling and walking tracks. Fishing, a nine-hole golf course, swimming, surfing and snorkelling are all offered. Self-contained accommodation, cabins and camping enable visitors to stay overnight.

Right: Typically, breezes blow from the Indian Ocean into Fremantle and whistle up the Swan River bringing refreshing afternoon coolness, known as the 'Freo Doctor'. The old Fremantle port is now a trendy place for eating, drinking and socializing especially around the lively Fremantle Markets.

Far right: Despite its wealth of beautiful stone Victorian buildings, the port of Fremantle was run down before being reinvigorated when the America's Cup sailing classic was contested here in 1987.

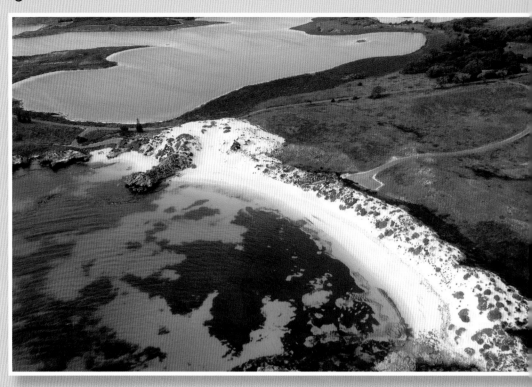

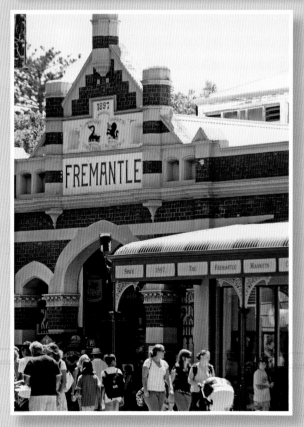

The Rest of the State

Just inland from Perth, the Swan Valley has various attractions including wineries, artisanal breweries and restaurants making it a recreational retreat for both locals and tourists. Superb wines are produced here and in other parts of the state, such as Blackwood, Geographe, Great Southern, Manjimup, Margaret River and Pemberton regions.

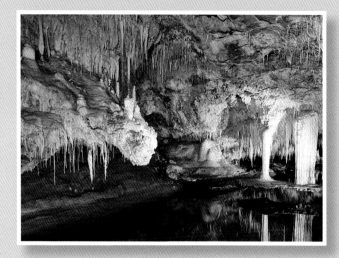

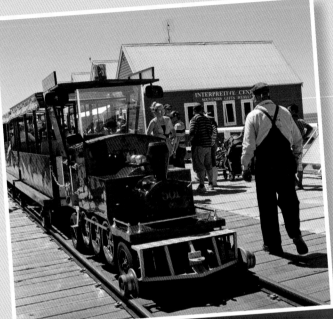

Above: Inside Lake Cave, a deep underground chamber 25 km (15 miles) south of Margaret River, delicate limestone formations are reflected in the pristine waters.

Left: Many tourists drive south from Perth to destinations such as Mandurah, Bunbury and Busselton. The 18-km (1-mile) long Busselton Jetty features a train ride to a spectacular underwater observatory.

Below: Adventurers can spend several days walking the trail from Cape Naturaliste southward to Cape Leeuwin (pictured) near Augusta.

Below: Ningaloo Reef is one of the few places in the world where it's possible to swim with Whale Sharks; the world's biggest fish (best from mid March to mid August). Fishing is also a favourite recreational activity along virtually the entire coastline.

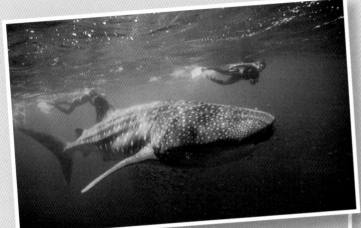

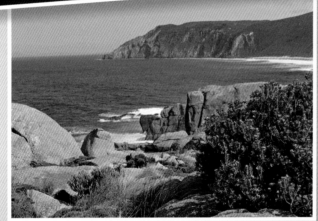

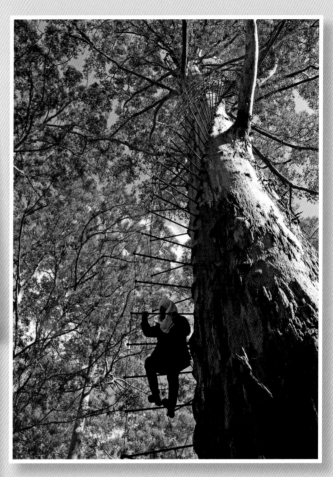

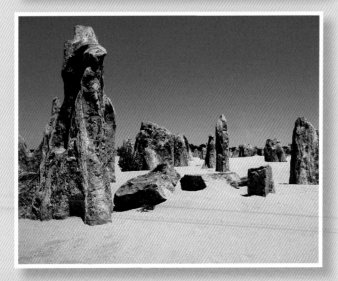

Above: Eucalyptus forests dominated by species called Jarra, Karri, Tuart and Red Tingle carpet the south-west. Exhilarating canopy views of Red Tingle trees are to be had at the Tree Top Walk in the Valley of the Giants near Walpole, while the Granite Skywalk affords panoramic, above-the-canopy views of the Porongurups and as far as the Southern Ocean. At Pemberton, adventurers can climb the Gloucester Tree to get a spectacular view of the Karri Forest.

Centre left: In Albany, the former Cheynes Beach Whaling Station at Discovery Bay can be inspected and natural features, such as The Gap – a 24 m (79 feet) deep gorge – and the Natural Bridge of granite are impressive attractions.

Left: Head north from Perth to tourist destinations such as The Pinnacles (moon-like, needle-shaped limestone formations) in Nambung National Park, Monkey Mia (to see dolphins), the town of Broome and the landscapes of The Kimberley and Pilbara.

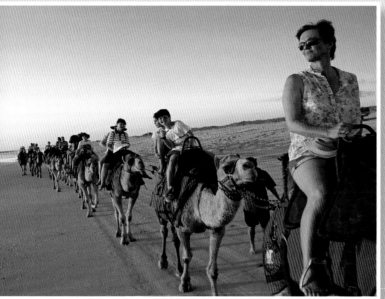

Left: Broome was once the pearl capital of the world. Pearls are still cultured offshore from the small town, which has a distinctly Asian feel due to the early pearl divers who settled here. It is now a beach resort destination where a sunset camel ride on Cable Beach is an essential activity. The annual beach polo event in May is a uniquely Australian sporting occasion.

Above: Wildflowers bloom year round but are best from June to September when parts of the state explode in a riot of colour.

Left: Much of the state is desert and includes the Nullarbor ('no trees') Plain and the Great Sandy, Gibson and Great Victoria Deserts. Kalgoolie is one of the earliest gold-mining towns in a state where boom and bust have been highlights of its history. Gold is still mined here and in other parts of the state, as are iron ore, aluminium, nickel and diamonds. Petroleum products are other important commodities sourced both on- and off-shore. The 'Indian Pacific' train passes through this desolate but colourful landscape.

Chapter 7: Brisbane and Queensland

Queensland is Australia's most popular holiday state for fun in the sun (with over 300 days of sunshine annually). Visitors can enjoy adventures both on the land and offshore with the Great Barrier Reef being a marine playground as well as the world's greatest marine biome. For those who want to get off the state's main tourist routes, Queensland is a vast state with many eco adventures in Cape York Peninsula and places in the outback like Mount Isa, Winton, Longreach and Birdsville.

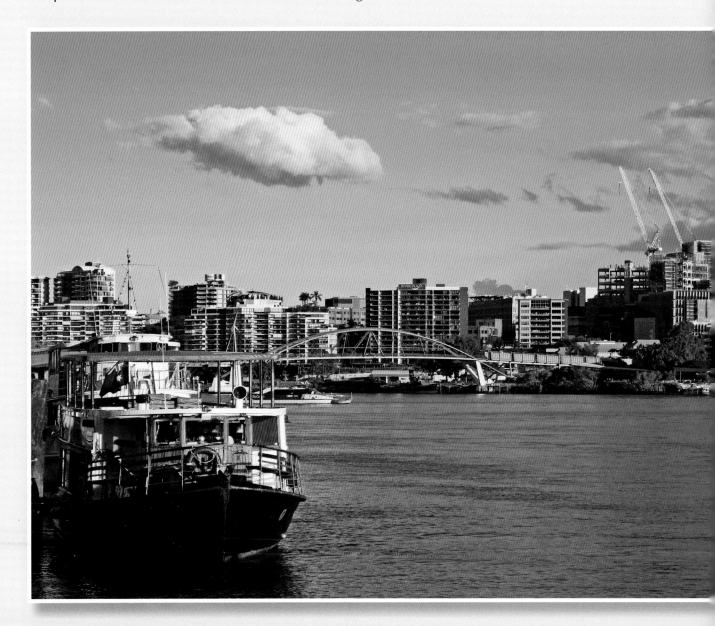

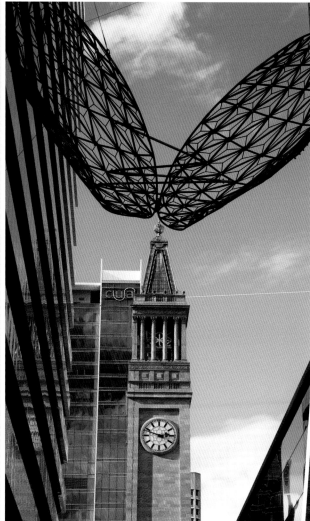

Left: Brisbane Town Hall on King George Square in the heart of the city is a heritage-listed building that was constructed between 1920 and 1930. It is well known for its iconic clocktower and the Museum of Brisbane housed inside.

Below: Brisbane Maritime Museum lies on the southern bank of the Brisbane River close to the city centre and the South Bank Parklands. It houses a collection of boats and memorabilia that are a part of Queensland's maritime history.

Opposite: The central parts of the state capital, Brisbane, sprawl on either side of the majestic Brisbane River where the residents enjoy activities like swimming, cycling, jogging and even rock climbing. It's possible to explore the river on a CityCat or cruise boat. Climbing across the Story Bridge is an adventurous activity for a fantastic perspective of this youthful and modern city – Australia's third largest with 2.04 million residents. Queen Street Mall is lined with department stores, boutiques and cafés while nearby South Bank is a well-used recreational area with the Gallery of Modern Art (GOMA) and Queensland Art Gallery close by. Further downstream Brisbane Powerhouse is another arts and cultural hub. Fresh produce is sold at the Riverside Market, South Bank and Rocklea Farmers' Market. Fortitude Valley is the hip-and-happening part of the city and there are dining precincts here and in Eagle Street Pier, Little Stanley Street, New Farm, the new Gasworks precinct and Portside Wharf.

The Gold Coast

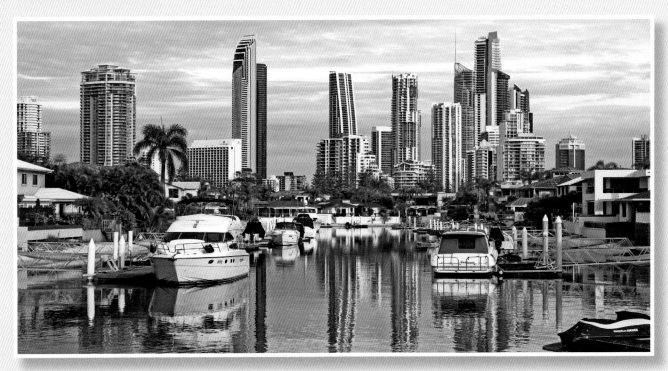

This page: Many sunseekers fly directly into Gold Coast International Airport to enjoy the glitzy life that extends from Coolangatta in the south to beyond Surfers Paradise in the north. Theme parks, beaches, golf courses, resorts, shopping malls (such as the massive Pacific Fair), restaurants, clubs, casinos and the site for the 2018 Commonwealth Games ensure that this is one of Australia's most vibrant holiday destinations. While the long stretches of golden sands attract tourists during the day, the active nightlife at the coast has equal appeal. Q1 at Surfers Paradise is the world's tallest residential tower with an observation deck on the 77th floor.

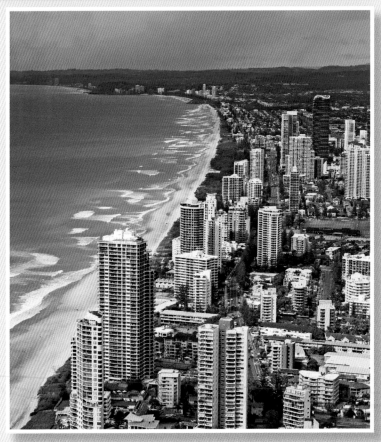

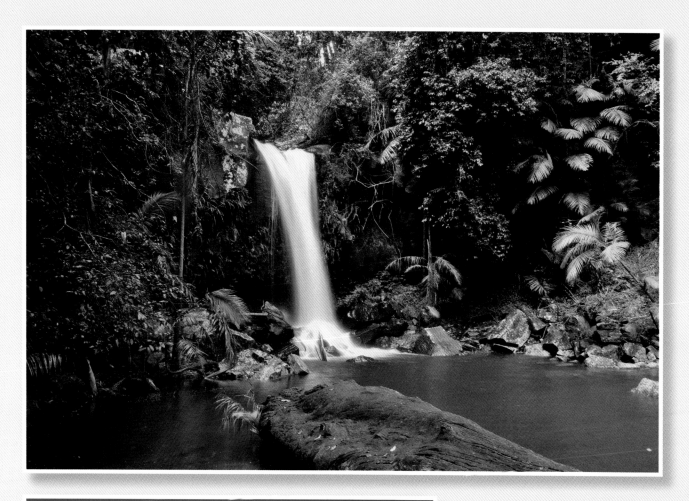

Above: There are many recreational activities in the Gold Coast hinterland with Mount Tamborine and O'Reilly's in Mount Lamington National Park being two sites that especially appeal to tourists. Quaint shops, rainforest walks, Curtis Falls (pictured), wineries, a microbrewery, a cheese factory and a distillery are all located in Mount Tamborine. There is also a tree-top walk and zip-lining through the rainforest canopy on a flying fox at Mount Lamington.

Left: Enjoy all the fun at themed attractions like Wet'n'Wild Water World, WhiteWater World, Australian Outback Spectacular, Dreamworld, Sea World (pictured) and Warner Brothers Movie World.

The Sunshine Coast

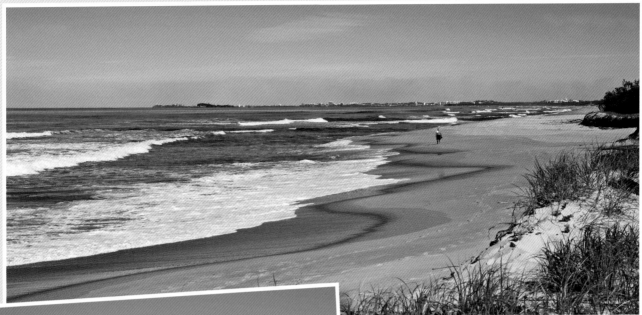

Above: Australia Zoo, established by the late crocodile hunter, Steve Irwin, is home to crocodiles and many iconic Australian and African animals. Highlights here include the Crocoseum and Bindi's Bootcamp for kids.

Right: There are several places to explore in the Sunshine Coast hinterland with the lively but laid-back Eumundi Markets being the place to be every Wednesday and Saturday.

Top: Holidaymakers also travel north to the Sunshine Coast and the seaside resorts of Noosa, Caloundra, Coolum (pictured) and Mooloolaba. Noosa is considered the chicest of all – Hastings Street is lined with restaurants, bars and boutiques. It backs onto Main Beach and Noosa National Park protects the headland.

Far North Queensland

Above: Cairns is the gateway for northern Queensland. Its remoteness, casual tropical lifestyle and the range of adventurous activities possible on the Great Barrier Reef make it a favourite, especially with backpackers. Travelling on the Kuranda Scenic Railway, experiencing Tjapukai Aboriginal Cultural Park, self-driving the food trails on the Atherton Tablelands and adventures, such as whitewater rafting on the Tully River, are popular activities.

Above left: Numerous resort islands and tourist towns dot the coast all the way from Bundaberg to beyond Cooktown in the far north. Islands include Lady Elliot Island on the Southern Great Barrier Reef, the Whitsundays (Hayman and Hamilton Islands), Magnetic Island, Fitzroy and Lizard Island to name just a few. Some of the 600 islands have luxurious resorts, such as this one on Hayman Island, that attract global travellers who come to admire the reef, to scuba dive, snorkel, swim and relax. Others like Heron Island appeal for their wildlife including turtles, birds and whales.

Above: Port Douglas is a chic town with several stylish resorts and many restaurants that are close to the popular Four Mile Beach. The town provides excellent access to diving and snorkelling sites, such as Agincourt Reef. Tropical rainforests in the Mossman Gorge, Daintree and Cape Tribulation are the other main attractions.

Chapter 8: Darwin and the Northern Territory

Known as the Top End, the Northern Territory is like one vast national park with a variety of habitats from lush wetlands to parched deserts, and different climatic zones which can affect the tourism experience. There are two distinct seasons – the wet (October to April) and the dry (May to September). It covers 1.35 million sq km (523,000 sq miles) or 20 per cent of the total Australian land mass. Its Aboriginal culture forms an integral component of the tourism assets. Its capital and largest city is Darwin and the outback town of Alice Springs is the only other substantive urban area.

Below: The main gateway to the state is Darwin, which has a tropical climate and a multiracial population; there are over 50 ethnic groups that call Darwin home. It is closer to some Asian cities than it is to others in Australia, giving Darwin's culinary scene and markets a distinctively Asian feel. Mindil Beach Sunset Markets feature hundreds of food and craft stalls.

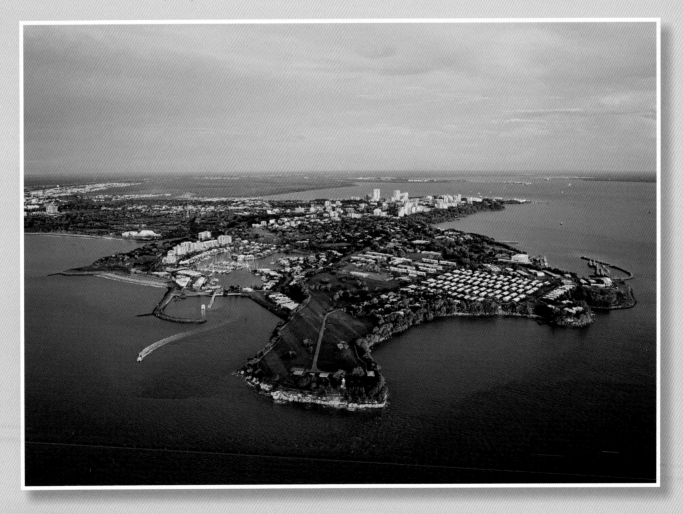

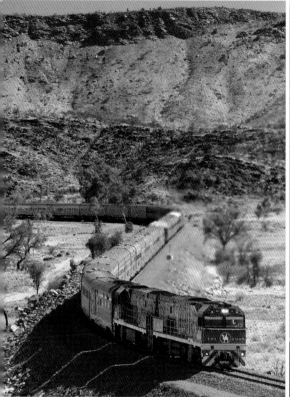

Left: Many tourists fly into Alice Springs to explore sites such as the Alice Springs Desert Park, Reptile Centre, Old Telegraph Station, School of the Air (a school conducted over the radio for children spread out over some 1.16 million sq km or 450,000 sq miles) and Royal Flying Doctor Service, as well as to enjoy flights over the spectacular MacDonnell Ranges. Others drive the 1 479 km (919 miles) via 'The Track', which is actually a sealed highway. 'The Ghan' train operates from Darwin to Adelaide passing through Katherine and Alice Springs along the way. Alice Springs in the MacDonnell Ranges in the south of the state is a large town and service centre for the region.

Below: The Northern Territory's outback (or 'Never Never') contains several iconic natural features in what is known as the Red Centre, including UNESCO World Heritage-listed Uluru (Ayers Rock) and Kata Tjuta (The Olgas), 460 km (285 miles) south of Alice Springs. Both are significant sites for the Anangu people, its traditional Aboriginal owners.

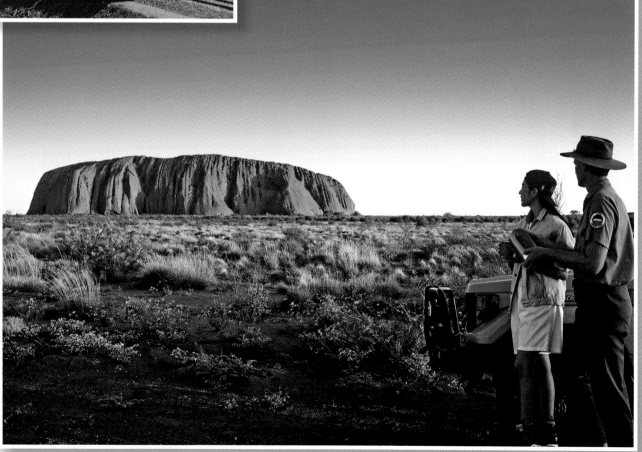

Kakadu National Park

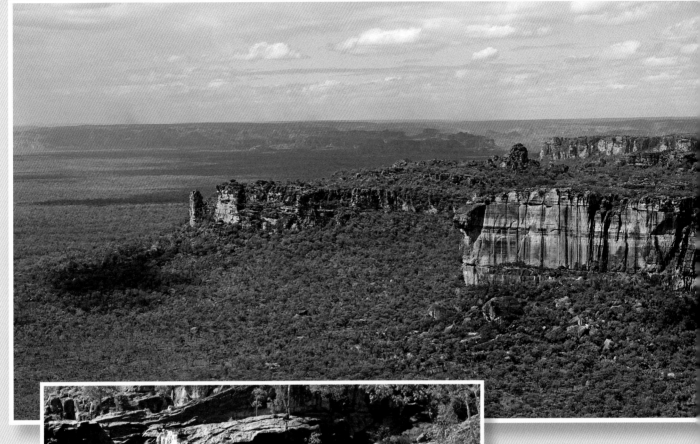

This page: *Kakadu National Park is a UNESCO World Heritage Site and the main natural attraction in tropical Northern Territory. This vast wilderness is home to wild rivers, extensive wetlands, crocodiles, sandstone escarpments and the cascading waterfalls of Jim Jim and Twin Falls. Ancient Aboriginal art is best viewed at sites such as Ubirr and Nourlangie.*

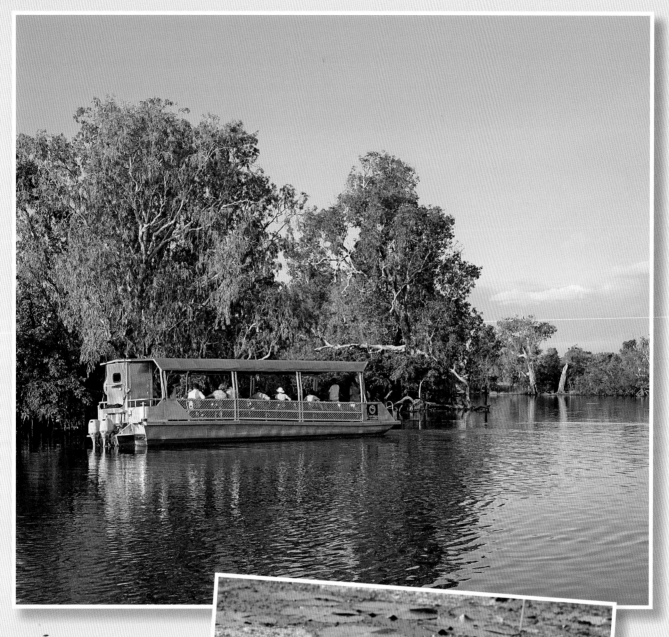

This page: One of the most popular wildlife tours to see crocodiles and waterbirds is along the Yellow River. There are two types of crocodiles in the Northern Territory; freshwater and saltwater and while both should be treated with respect, the latter is more aggressive.

Chapter 9: Hobart and Tasmania

With an area of 68,331 sq km (26,376 sq miles), the island of Tasmania is Australia's smallest and only island state (there are actually 300 other islands in the archipelago). No destination is more than 115 km (71 miles) from the coast and life moves at a decidedly slower pace. Hobart, the capital, and Launceston in the north are the two main city destinations and air gateways, while ships provide overnight sea connections for passengers and cars between Melbourne and Devonport. Tasmania was part of mainland Australia until 12,000 years ago when rising sea levels formed the Bass Strait. The traditional owners lived here well before the island was established as a penal colony in 1803 (it was then known as Van Diemen's Land).

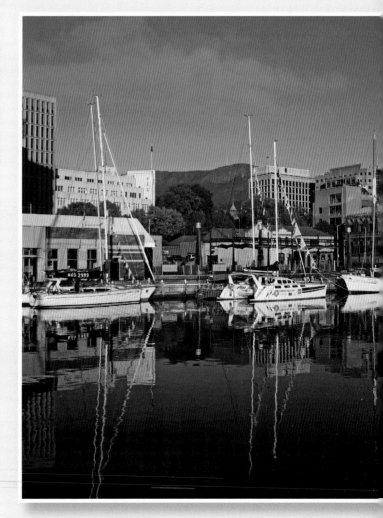

While it is the coolest of the Australian states, Tasmania's climate is still temperate with an average minimum winter temperature of 4 °C (40 °F) and surprisingly, Hobart has the second lowest rainfall of all Australian capitals. The island is clean, green and pure (Cape Grim has the world's cleanest air) and sampling Tasmanian produce from seafood to leatherwood honey and cool, temperate wines is a highlight for most tourists.

View the city and picturesque harbour on a Tasmanian Air Adventure seaplane that departs from the docks.

Right: Hobart is home to some 220,000 residents (Tasmania's total population is 500,000) and it has a welcoming, small-town atmosphere. It is Australia's second oldest city after Sydney. Hobart overlooks the expansive Derwent River and Mount Wellington, at 1,271 m (4,170 ft), forms a backdrop that is occasionally dusted with winter snow. Hobart's Museum of Old and New Art (MONA) has made the city a significant destination for art lovers. The Moorilla Estate Winery, an integrated tourism destination, features artworks displayed in an underground labyrinth and in gardens overlooking the sparkling harbour. History also plays a leading role in the state's tourism with the remains of the Port Arthur penal colony being an important site.

Above: Richmond (pictured) and New Norfolk are historic villages near Hobart that are home to gracious and preserved sandstone buildings.

Below: Some 40 per cent of the island is protected as World Heritage Areas, reserves or national parks and activities in nature attract many tourists. It's the only place in the world to see wild Tasmanian Devils (pictured), Spotted-tail Quolls and Eastern Quolls.

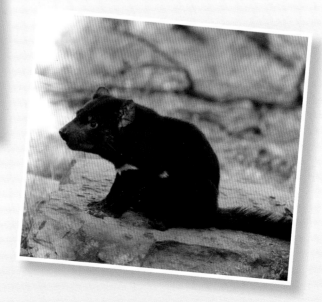

Above: Hobart's harbour is lined with historic docks, fishing trawlers, seafood restaurants, boutique hotels and the famous Saturday Salamanca Market. The area, dominated by 19th century Georgian sandstone buildings, comes to life when the markets are staged and when the Sydney to Hobart yacht fleet arrives into Constitution Dock at the end of this classic, blue-water yacht race in late December.

Around Tasmania

Right: In the north, Launceston (population 90,000), is set on the banks of the Tamar and Esk Rivers. Vineyards line the lower slopes beside the Tamar. Places to visit include the Queen Victoria Museum and Art Gallery, the Seaport Precinct, Cataract Gorge, the Sunday markets in Evandale and Bridestowe Lavender Farm at Nabowla (the flowering season is December and January). Barnbougle Dunes and Lost Farm Golf Courses near the windswept town of Bridport have quickly established themselves as two of the world's finest links courses.

Right: From Launceston, it's possible to drive to Cradle Mountain-Lake St Clair National Park via Sheffield, the town of murals. Glacial formations of peaks, lakes and U-shaped valleys dominate the national park. Extended walks are popular, such as the classic Overland Track in Cradle Mountain or the Bay of Fires on the east coast. Shorter walks can be taken around Dove Lake at Cradle Mountain. On the east coast, guests can stay in Saffire Freycinet, which has won an award as the world's best boutique hotel.

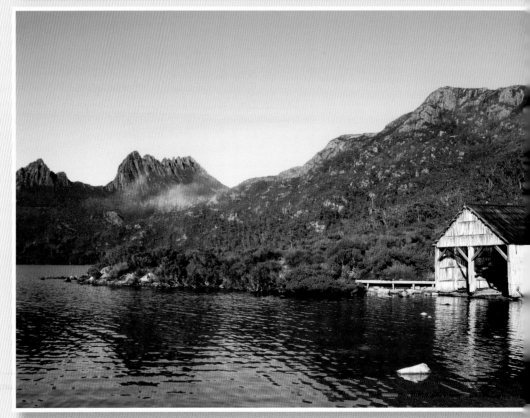

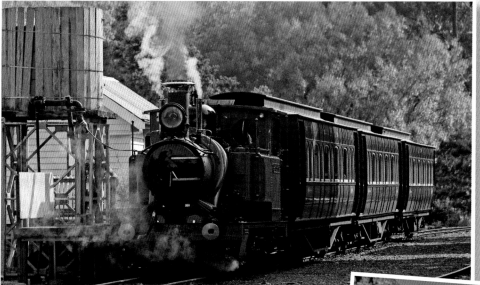

Left: Strahan on the south-west coast provides access to Macquarie Harbour and the convict settlement on Sarah Island, the Gordon River cruise and the West Coast Wilderness Train to Queenstown.

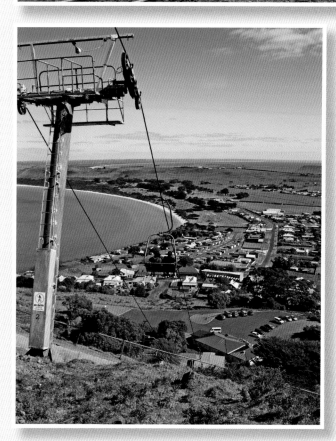

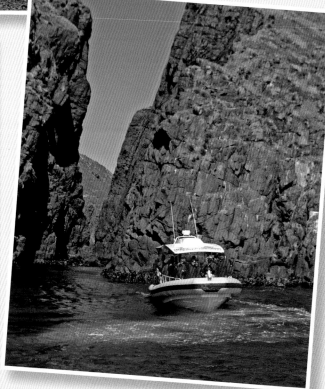

Above: Tasmania's north coast is dotted with towns, such as Burnie and Wynyard, plus seafront villages, such as Stanley, where riding the cable-car to the top of 'The Nut' is one of several great reasons for visiting.

Above: One of the most important natural attractions in the east of Tasmania is the Freycinet National Park where Wineglass Bay has been voted as one of the world's best beaches. Walks and cruises provide access to the fine white sands here. Further south, Bruny Island (pictured) is a sleepy destination for holidaymakers. It's also the departure point for coastal adventures operated by Bruny Island Cruises to see dramatic coastlines and a seal colony.

Getting About

Australia is a huge country with a relatively small population living in scattered centres, which means that there are vast empty regions and gaining access to the most remote areas requires long flights or a longer road journey. The national carrier is Qantas (the shortened version of Queensland and Northern Territory Air Service), which flies to all continents (including charter flights over Antarctica). The 'Kangaroo Route' from Australia to London once involved 42 refuelling stops over 12 days. Air travel to Europe can now be done in around 24 hours with one stopover. Virgin Australia also operates overseas and domestic flights. Several other domestic airlines provide services between the capital cities and regional destinations. In remote areas, the Royal Flying Doctor Service provides essential medical aid.

Below: Some of the best ferry journeys in the world are on Sydney Harbour ferries, which mostly depart from Circular Quay to various parts of the harbour including the famous beachside suburb of Manly.

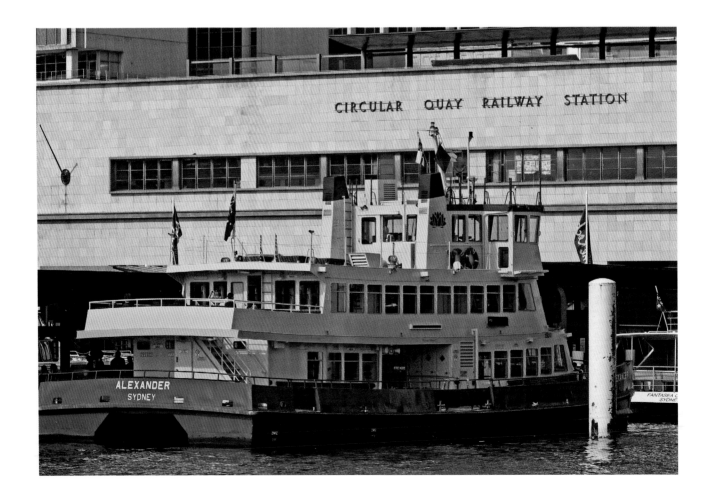

Many Australians own a car and use it regularly, driving on the lefthand side of the road. Some tourists choose to rent campervans and motorhomes for extended travel throughout Australia. Dirt roads and 4x4 vehicles are also quite common in remote parts of the country. Most goods are transported around the country by truck with extra long 'road trains' being features of outback roads.

For rail enthusiasts, there are classic train journeys, such as the Indian Pacific Railway, which is a 4,377-km (2,720-mile) long, three-day adventure from Perth to Sydney or the 54-hour-long trip on *The Ghan* from Darwin to Adelaide (2,979 km/1,851 miles), including the world's longest stretch of straight railway, 478 km (297 miles), across the Nullarbor Plain from Ooldea to beyond Loongana (see page 61).

Australia's most famous ferry crossings are those on Sydney Harbour with the journey from Circular Quay to Manly being an essential trip for all visitors. Vehicular and passenger ferries operate between Melbourne and Tasmania (Devonport) and Cape Jervis south of Adelaide to Penneshaw on Kangaroo Island. Ferries also operate to Rottnest Island off Fremantle and across Port Phillip Bay from Queenscliff to Sorrento.

Buses, trains and trams provide intracity connectivity with the trams of Melbourne and Adelaide being an essential part of the urban landscape.

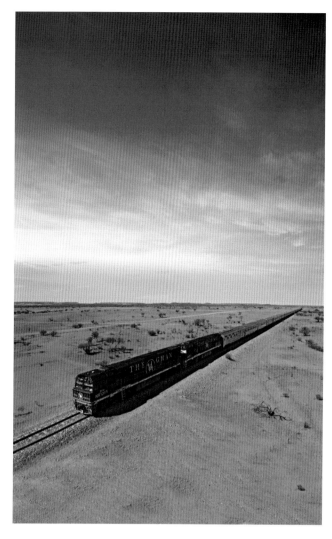

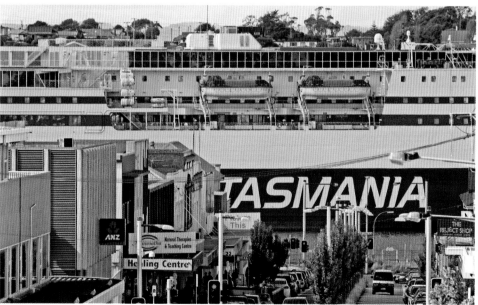

Above: *Great Southern Rail operates 'The Ghan' train which takes 54 hours to cover the 2,979 km (1,851 miles) from Darwin to Adelaide.*

Left: *Car and passenger ferries operate between Melbourne on the mainland and Devonport on the island of Tasmania.*

Resources

CONTACTS

Australian Capital Tourism: www.tourism.act.gov.au

South Australia Tourism Commission: www.visit-
 southaustralia.com.au

Tourism and Events Queensland: www.queensland.com

Tourism New South Wales: www.visitnsw.com

Tourism Northern Territory: www.tourismnt.com.au

Tourism Tasmania: www.tourismtasmania.com.au

Tourism Victoria: www.tourismvictoria.com.au

Tourism Western Australia: www.westernaustralia.com

REFERENCES

Books

Bryson, B. 2000. *Down Under*. Doubleday.

Kelly, A. and Bowden, D. 1988. *Countries of the World,
 Australia*. Wayland.

Pilger, J. 1989. *A Secret Country*. Random House.

Films

Mad Max (1979)

Picnic at Hanging Rock (1975)

Crocodile Dundee (1986)

The Year My Voice Broke (1987)

Dead Calm (1989)

Strictly Ballroom (1992)

Muriel's Wedding (1994)

The Adventures of Priscilla, Queen of the Desert (1994)

Babe (1995)

Shine (1996)

Rabbit-Proof Fence (2002)

The Proposition (2005)

Happy Feet (2006)

Australia (2008)

ACKNOWLEDGEMENTS

Many people contributed valuable information and feedback in the preparation of this book. Particular thanks go to John Arthur, Joel Backwell, Tim Barbour, Liz Bowden, John Gordon, Cassandra Graham, Brianna Delaporte, Jacqueline Lee, Bernard O'Callaghan, Selena Oh, Narelle McMurtrie, Chris Pritchard and Shelley Winkle.

ABOUT THE AUTHOR

David Bowden is a freelance photojournalist based in Malaysia who specializes in travel and the environment. While Australian, he has lived in Asia for longer than he can remember and returns to his home country as an enthusiastic tourist. When he's not travelling the world, he enjoys relaxing with his wife Maria and daughter Zoe. He is also the author of several other titles in the *Enchanting* series.

Index

First published in the United Kingdom in 2015 by John Beaufoy Publishing,
11 Blenheim Court, 316 Woodstock Road, Oxford OX2 7NS, England
www.johnbeaufoy.com

ISBN 978-1-909612-51-8

Designed by Glyn Bridgewater
Cartography by William Smuts
Project management by Rosemary Wilkinson

Printed and bound in Malaysia by Tien Wah Press (Pte) Ltd.

All photos by David Bowden except for: EcoPrint (p12); Great Southern Rail
(p61 bottom, p69 top, p77 top); Port Stephens Tourism (p40 top); Queensland
Tourism (p65 top and bottom); Sheraton Macao (p16 bottom); South Australia
Tourism Commission (p20, p55 top and bottom); Tourism NSW (p41 top);
Tourism Northern Territory (p68, p69 bottom); Tourism Victoria (p6, p15 bottom,
p30, p31 top, p42, p44 top, p45 bottom, p48 and p49); and Tourism Western
Australia (p2, p31 bottom, p57 top and bottom, p58 top, p60 top left).

Cover captions and credits
Front cover (top, left to right): *Vintage Melbourne tram* © CTR Photos/
Shutterstock.com; *Uluru (Ayer's Rock)* © Wesley Walker/Shutterstock.com;
Sydney Harbour © Dan Breckwoldt/Shutterstock.com; *Koala Bear* © David
Bowden. Front cover (centre): *The Indian Pacific train crossing Nullarbor Plain*
© David Bowden. Front cover (bottom): *Port Stephens* © David Bowden. Back
cover (left to right): *Iconic bell tower, Perth* © Tourism Western Australia;
Adelaide from Riverside Park © David Bowden; *The famous clock tower,
Brisbane* © David Bowden; *Hobart, Tasmania* © David Bowden.